The N Word of God

Mark ✻ Doox

"This double-consciousness, this sense of always looking at one's self through the eyes of others, of measuring one's soul by the tape of a world that looks on in amused contempt and pity. One ever feels his twoness, – an American, a Negro; two souls, two thoughts, two unreconciled strivings; two warring ideals in one dark body, whose dogged strength alone keeps it from being torn asunder."
— W.E.B. Du Bois, The Souls of Black Folk

"I will gag all braggarts and boasters – not a peep will be heard anymore from them and I shall trip strutting tyrants, leaving them flat on their faces. The proud will disappear from the earth. And because of this...mortals shall be rarer...than hens' teeth."
— Isaiah 13

Editor: Gary Groth
Assistant to the Editor: Breelyn Mangold
Cover Design: Mark Doox and Kayla E.
Interior Design: Mark Doox and Kayla E.
Production: Paul Baresh and C Hwang
Promotion: Jacq Cohen
VP / Associate Publisher: Eric Reynolds
President / Publisher: Gary Groth

Follow Mark on X (formerly known as Twitter) and Instagram @markdoox and to view more of his art and projects visit MarkDoox.com

The N-Word of God *is copyright © 2024 Mark Doox. This edition is copyright © 2024 Fantagraphics Books Inc. All Permission to reproduce content must be obtained in writing from the publisher. All rights reserved. Fantagraphics Books and the Fantagraphics Books logo are trademarks of Fantagraphics Books Inc.*

*7563 Lake City Way NE
Seattle, Washington, 98115
Fantagraphics.com
Follow us on Twitter and Instagram @fantagraphics
and on Facebook at Facebook.com/Fantagraphics.*

*ISBN: 978-1-68396-939-6
Library of Congress Control Number: 2023943827
First printing: 2024
Printed in China*

The N Word of God

Mark * Doox

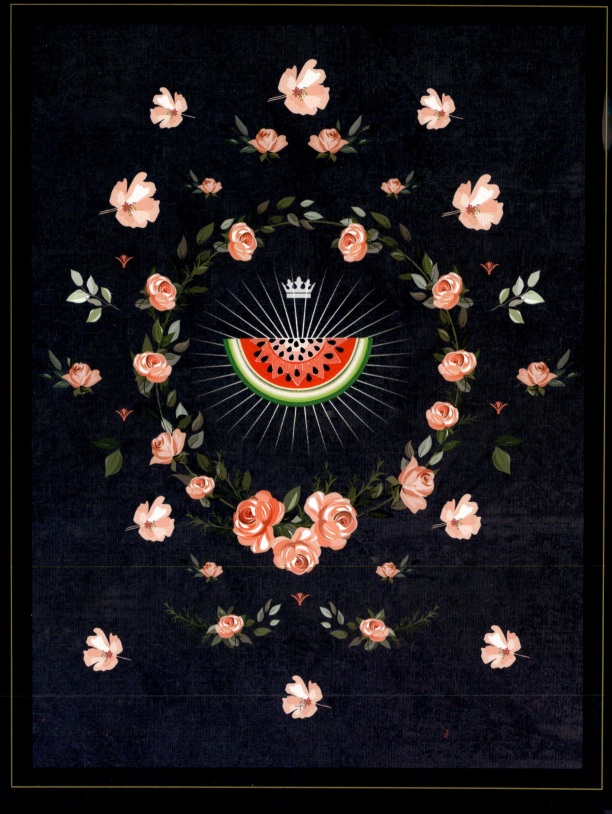

BOOK ONE

The N-Word of God

*The Shine of
the Whole World*

*The Song of the
N-Word of God*

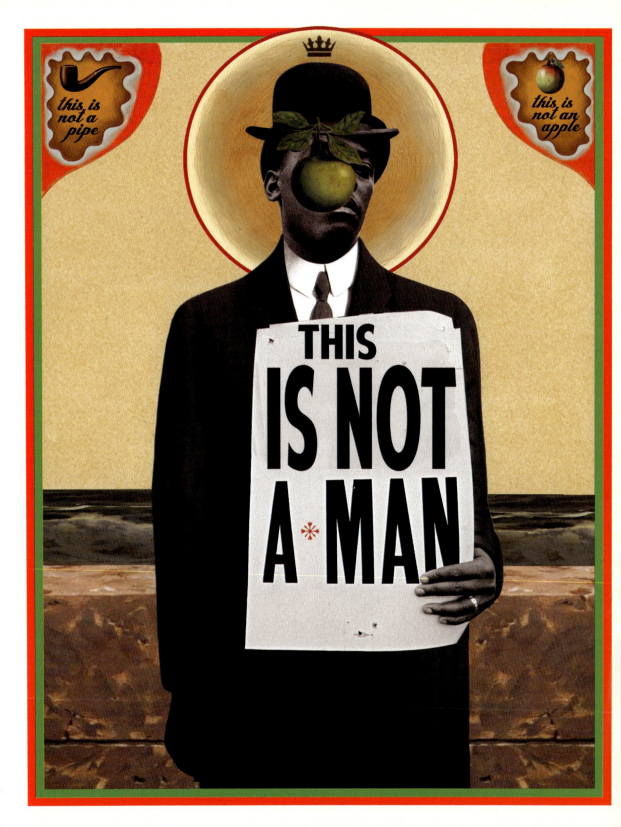

The Shine of the Whole World

OPPOSITE PAGE: *"Son of Man" (After Adelman and Magritte) or "Nevertheless, I Am a Man/The Treachery of Images."*

In the beginning, there was God.

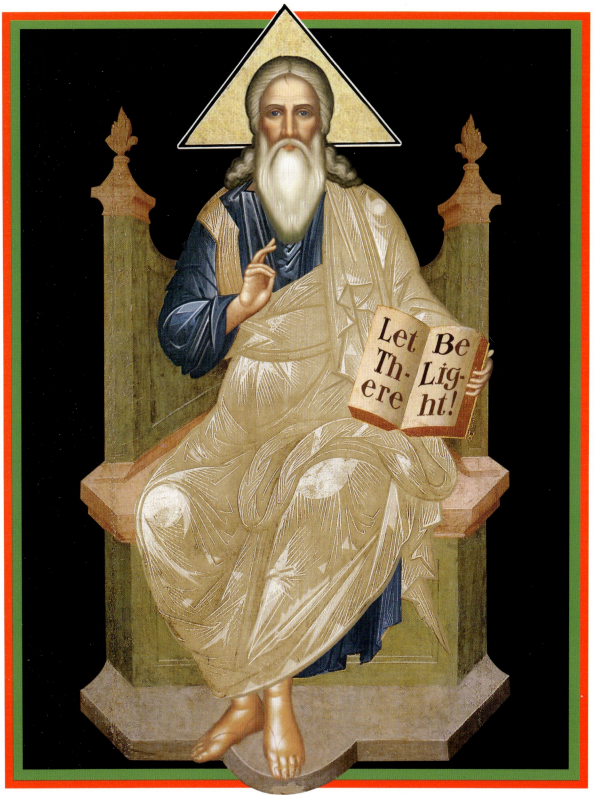

And God said…
"Let there be light."
…and there was light!

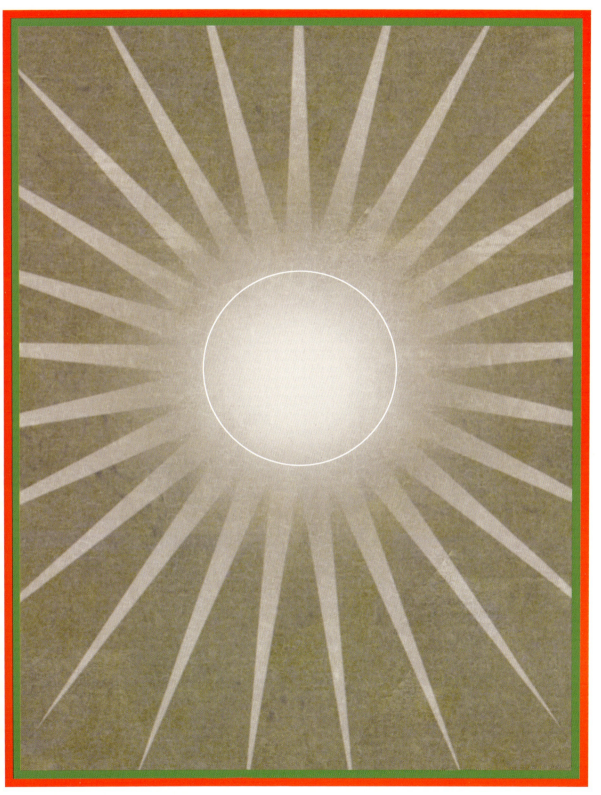

Thus, it was at the
beginning with God.

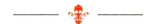

And the Dark fled the Light upon the very instant Light was created (because the Darkness is the absence of Light).

Therefore, Light and Darkness were in opposition to each other from the very beginning.

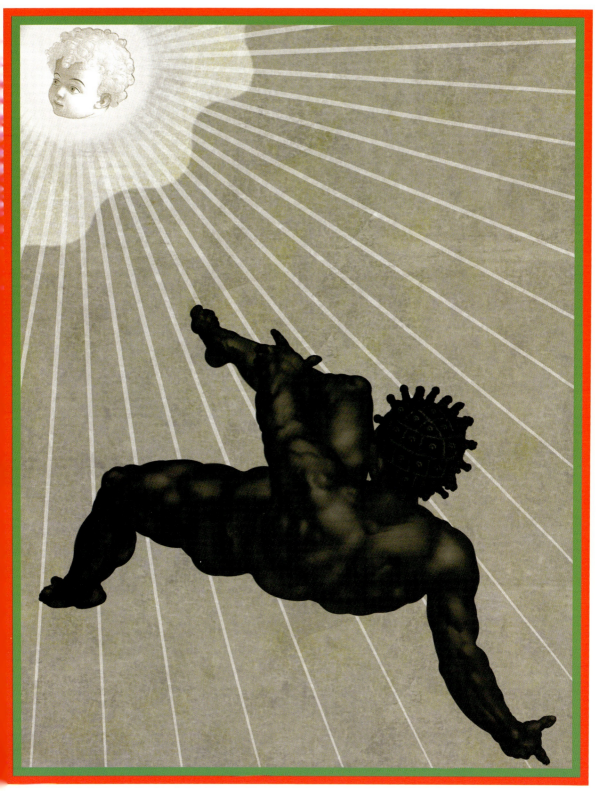

Now, the Light knew that Darkness had existed before it, and with great pride, Light pursued Darkness seeking out anyplace it might be hiding.

"Come here, Darkyness." Light taunted. "Come here."

The Light had given the Darkness a cute and meaningful name!

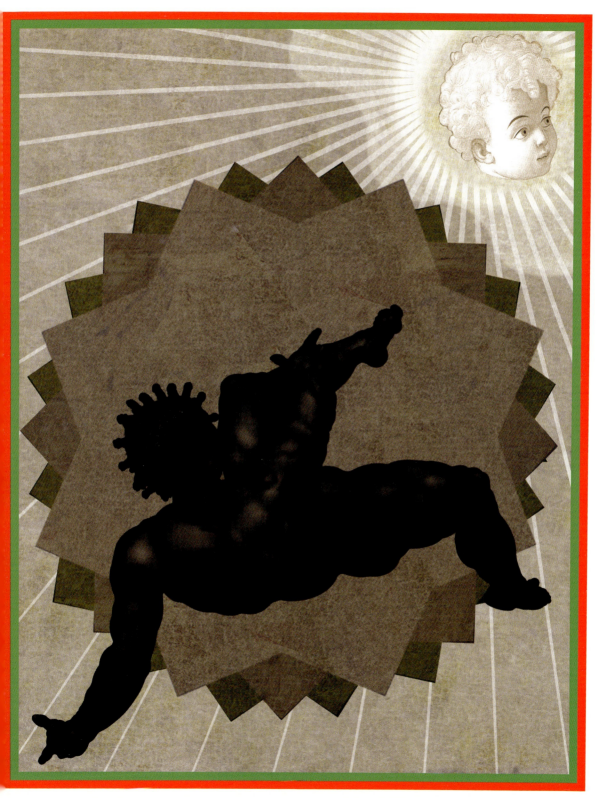

Light spoke in this manner because Light felt superior to "Darkyness." Light saw itself as special and that it had a Manifest Destiny.

"For whatsoever doth make manifest is light,"* Light said to itself. "Isn't that in the Word of God someplace? And, I am no ordinary light. I am the white light. The purest and the brightest kind of light there is.

"And you can't get any darker than jet black, Darkyness. Ha! Ha! Ha!" Light said, as it spied and looked upon where the last vestige of "Darkyness" was hiding behind a paltry display of illusory power.

*Ephesians 5:13

And Light, upon casting its eyes toward that hiding place of Darkness, fully saw Darkness there. And Light opened wide its maw in preparation to devour and thus thinking to eradicate Darkness from all existence forever.

"Don't blame me," Light said to Darkness.

"My dominion is merely the will of God."

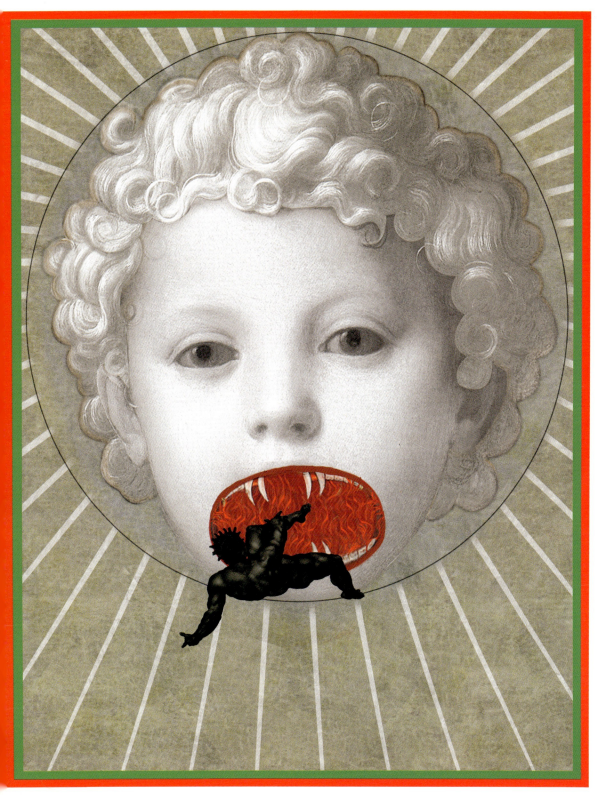

But God had other ideas.

For God looked upon the fleeing of "Darkyness" and decided to have mercy on it. For even though God was associated with Whiteness and Lightness, and it is said that in Him is no darkness and no shadow of turning, God was still God, was He not? And is it not written that not only is God Almighty and God is Lord…but also, "God is Love"?

So, God moved. And God acted — very quickly. In an instant. Nay, a fraction of a moment…

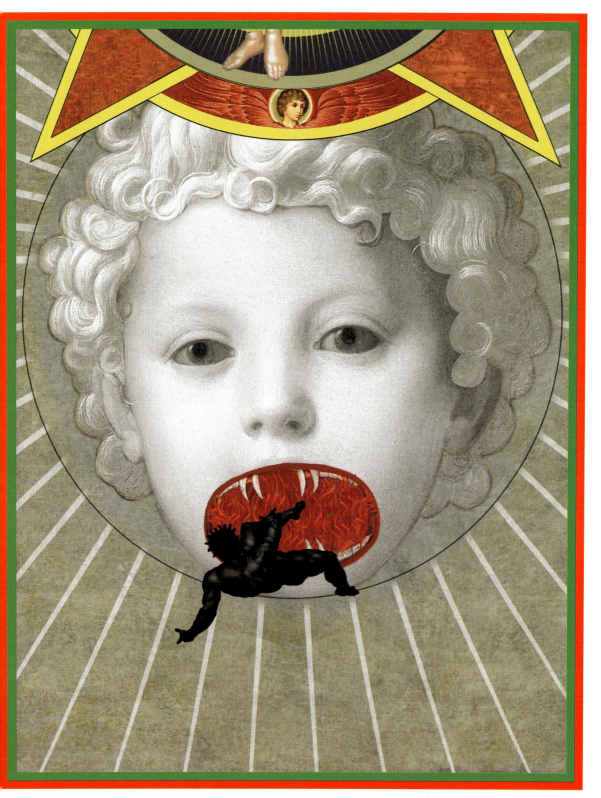

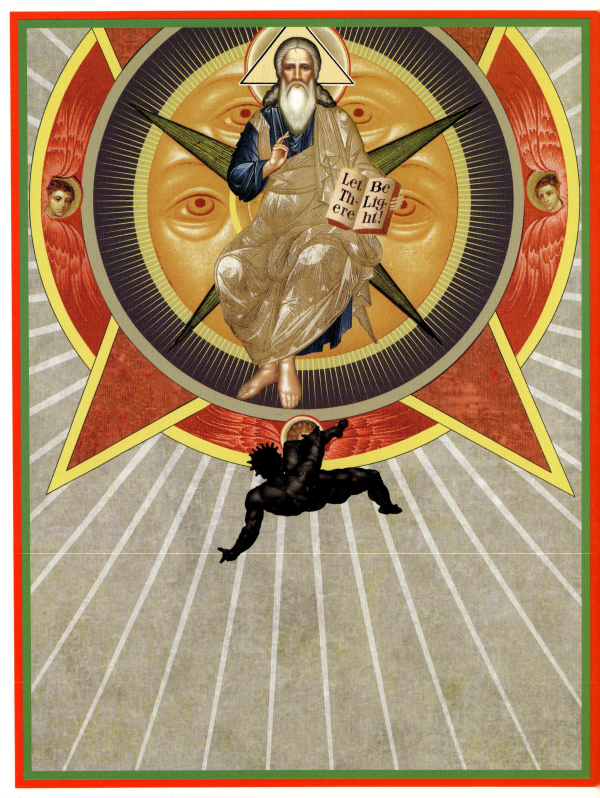

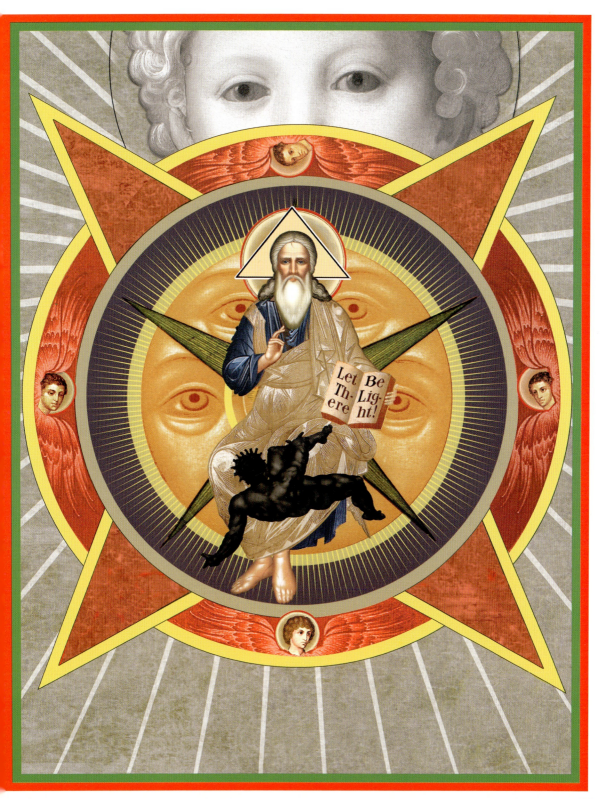

So God positioned Himself between Light and Darkness!

And, as a matter of course, the backside of God faced rearward toward Light for *the first time*. (This is significant.) For Light's WHITE LIGHT *shined upon that which was newly shown and revealed by God.*

Then God spoke a mysterious and confusing word to Darkness, making Darkness scratch its head with puzzlement.

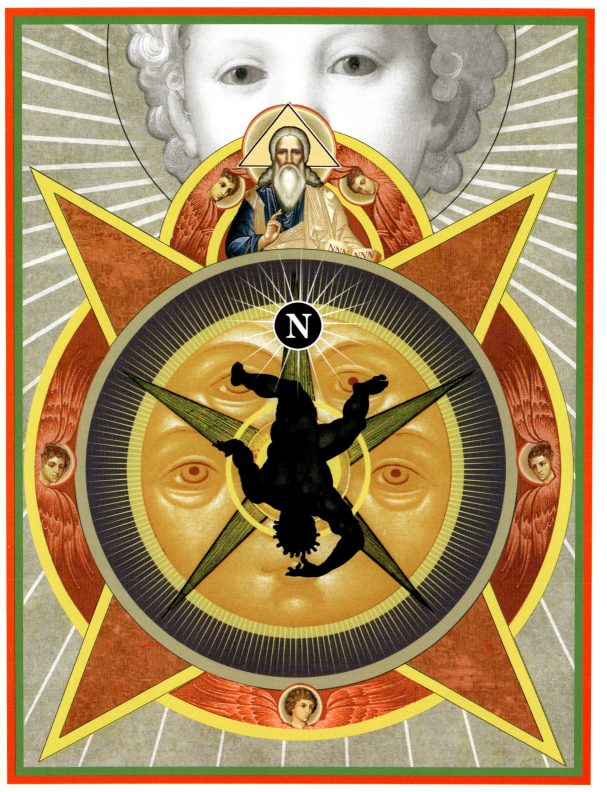

Now, this word that God spoke was supreme *Black* wisdom, a MYSTERY, even of how Darkness might in due course—put on Light itself, be clothed by it, and SHINE!

This mysterious word that God spoke to Darkness quickly formed in the initial thought of the very consciousness of Darkness…How fast it grew!

For the word was received in Darkness as if it was planted in rich black soil that had made wise accommodation for the seed of it. And thus, the word grew…And GREW!

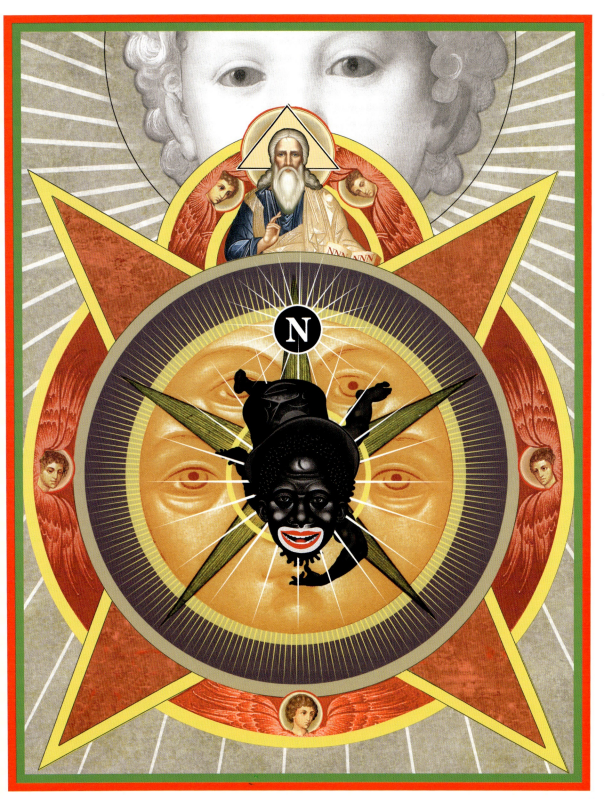

Few have heard of this word.

Fewer still have understood it.

But, for those that have heard and have understood it, to them, it is the truth of "Darkyness," and this is no lie.

And the word that God spoke consisted of only one letter. That letter is the letter N, and this is most appropriate, is it not?

For, what is that mysterious word that God spoke to Darkness?

That word that God spoke to Darkness is called none other than…

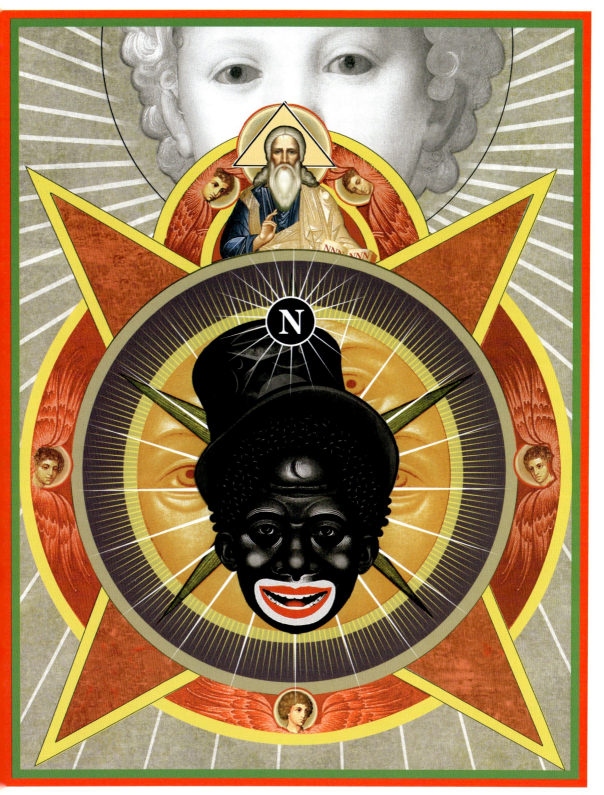

...the N-Word of God!

(And it is pronounced like this. "...NNN
NNNNNNNNNNNNNNNNNNNNNN
NNNNNNNNNNNNNNNNNNNNNN
NNNNNNNNNNNNNNNNNNNNNN
NNNNNNNNNNNNNNNNNNNNNN
NNNNNNNNNNNNNNNNNNNNNN
NNNNNNNNNNNNNNNNNNNNNN
NNNNNNNNNNNNNNNNNNNNNN
NNNNNNNNNNNNNNNNNNNNNN
NNNNNNNNNNNNNNNNNNNNNN
NNNNNNNNNNNNNNNNNNN...")

Without beginning. Without end.

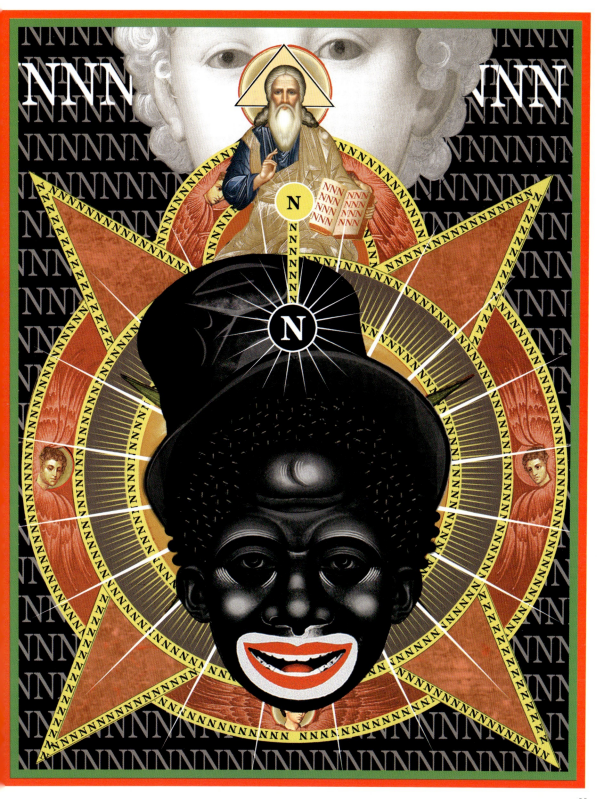

And *the N-Word of God* was made flesh and dwelt among us.

Many have beheld his glory, even the glory of God's only misbegotten son! He is the light of the existential dilemma of "Darkyness" called the *ENIGGERMA*.

And verily, he is the Shine of the Whole World and has, thereby, given spiritual gifts unto **all** humankind.

For he has preached the highest of all Black wisdom.

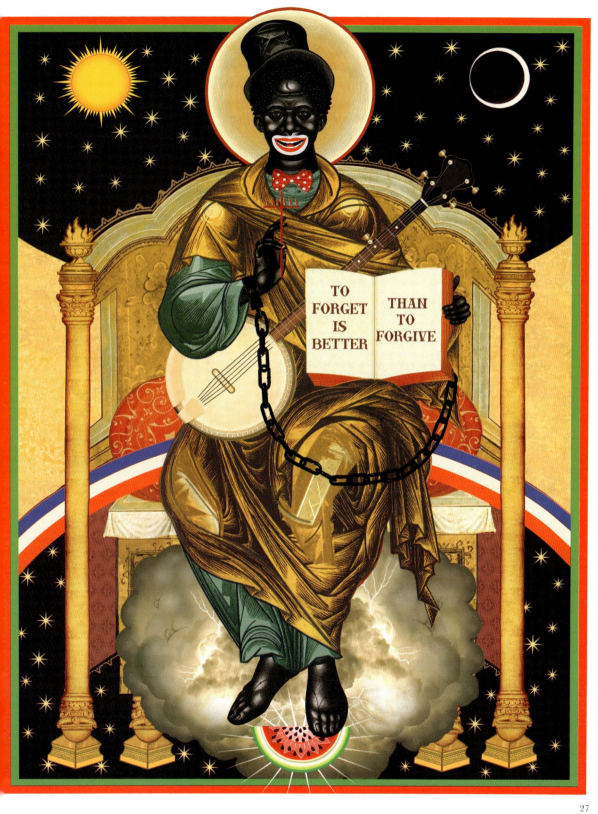

Saint Sambo is the Shine.

Saint Sambo is that Shine that transforms the darkness of Black flesh into white light.

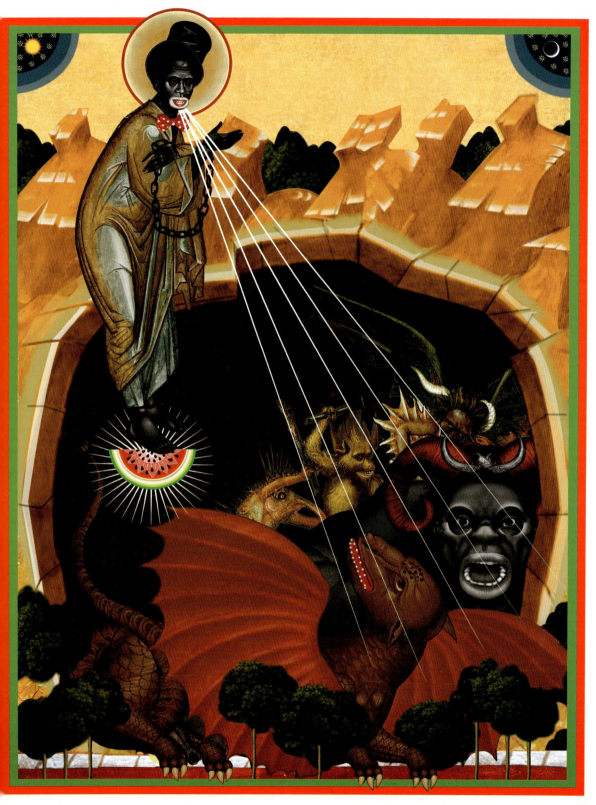

Saint Sambo is that Shine that shines from the face of whomsoever is humbled by the Principalities and the Powers of this age and yet perceives wisdom in smiling, complying, and maintaining a pleasing and good mood and thereby survives against many odds, against spiritual and earthly might in high places — even finding great favor where none appeared before.

OPPOSITE PAGE: *"Saint Sambo Travels to Monticello to Ask for a Small Business Loan and Is Hindered by Certain Evil Spirits on the Way."*

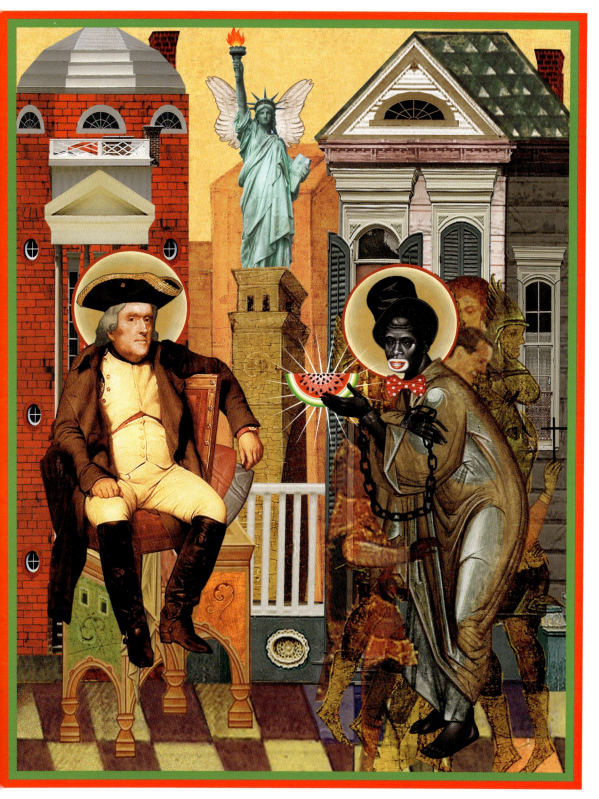

Saint Sambo has demonstrated great zeal.

OPPOSITE PAGE: *"George Washington Crosses the Middle Passage. Saint Sambo Dives Overboard and Swims to Davy Jones' Locker to Preach to the Black and the Dead Found There."*

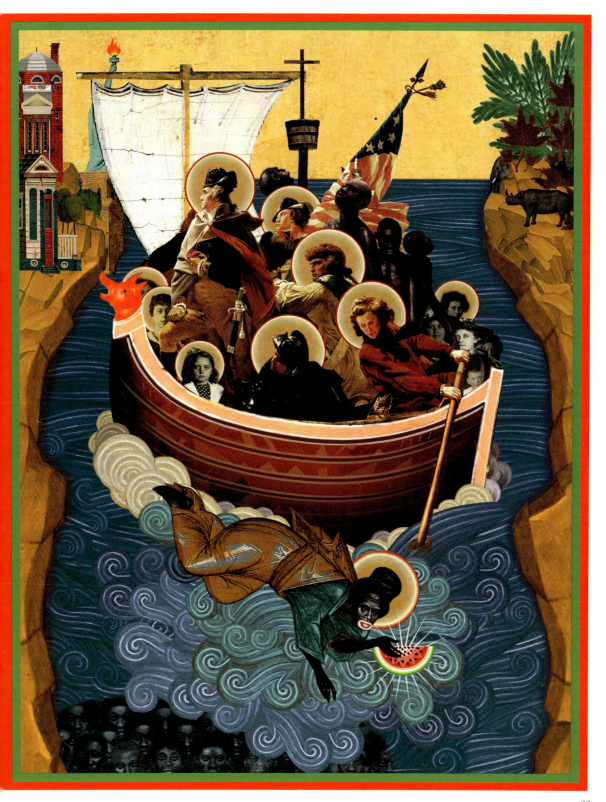

He was even willing to preach to the Black and the Dead so that they might too partake of the newness of life that he offers. Such was his zeal.

"Hella-lujah! Hella-lujah! Hella-lujah!" One might say.

Because sometimes in Americoonia, there is a little hell in every "Hello!" and a little, 'hella-lujah' in the hallelujahs of our Amerikkkcoonian praise.

OPPOSITE PAGE: *"Saint Sambo Preaches to the Black and the Dead of the Middle Passage, Even Those That Reside in Davy Jones' Locker and many are converted though they are dead, and many receive their own personal Watermelon Grin of Grace. Some even conduct spontaneous acts of communion and thereby receive grace and joy."*

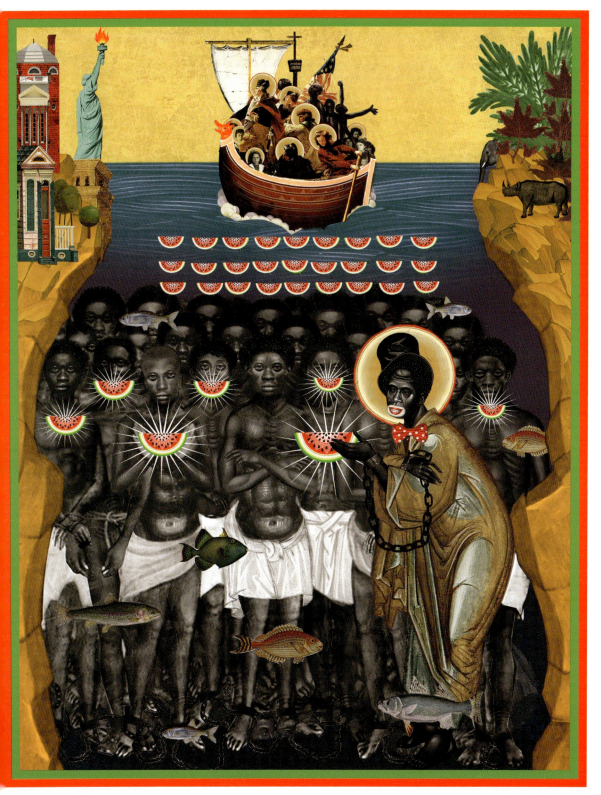

When he came to his own, many of his own hated him. But as many as received him, to them gave him the power to become children of shine.

For the law has come through Moses, grace, and truth through Jesus Christ. But what of the all-pleasing Grin of Grace through which the ancestors did survive by putting it on daily and constantly?

That Grin of Grace has come to us through Saint Sambo, whom some call the Coon Christ, and others call Black Jes'U.S. Christ, and who is the very shine of this world.

And arguably by his spirit and wisdom, we, the Black-kind, have survived.

For we must remember there were times past when any White person could harm or kill any Black person that displeased them, and little would be done about it.

Except, perhaps, in some cases, a White person would need to reimburse another White person for the damage or destruction of his peculiar Black property.

So let us not forget this doctrine of being pleasing, which we might also call — "Whiteousness."

For through the Coon Christ, we receive the wisdom of how not to be angry at anything done to us (past or present) and how to comply in all circumstances happily, and thusly, how we might prosper against all the odds in a land of so much White might and apparent ill will toward us. (We do this by our smile and our bright demeanor.)

For this reason, we of the Black-kind know Saint Sambo — even if we dislike him, deny him, reject him, or have not yet known his proper name until now.

And therefore, the Black and the Wise Ones have come to see that Saint Sambo is the very uncreated Light of that which is called the ENIGGERMA, and he is the Shine of the Whole World.

For they understand that there is the genuine Light of Christ and the genuine Shine of the Coon Christ. And though the Light and the Shine intersect, they are not precisely the same.

One, verily, like the sun. The other, verily, like (and likes) the white moon.

OPPOSITE PAGE: "Saint Sambo in the Wilderness Being Tempted by the Demon of Black Rage and His Minions. (The Demon of Black Rage is called Buck Nigg-Arrrgh! And he is the king of black demons.) The Devil used this opportunity (after Saint Sambo's visions on Mount Revelation) to try to move Saint Sambo to rage, wrath, and hatred. Saint Sambo successfully resisted the Devil's machinations through communion with the Sacred Fruit and fervent contemplation of the Wisdom of its Divine Watermelon Grin, thereby receiving more grace for the tasks that lay ahead of him."

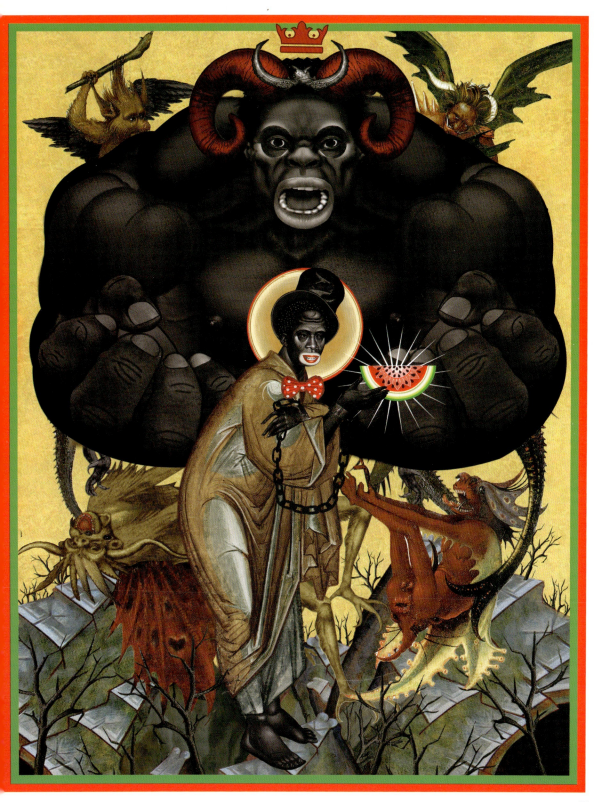

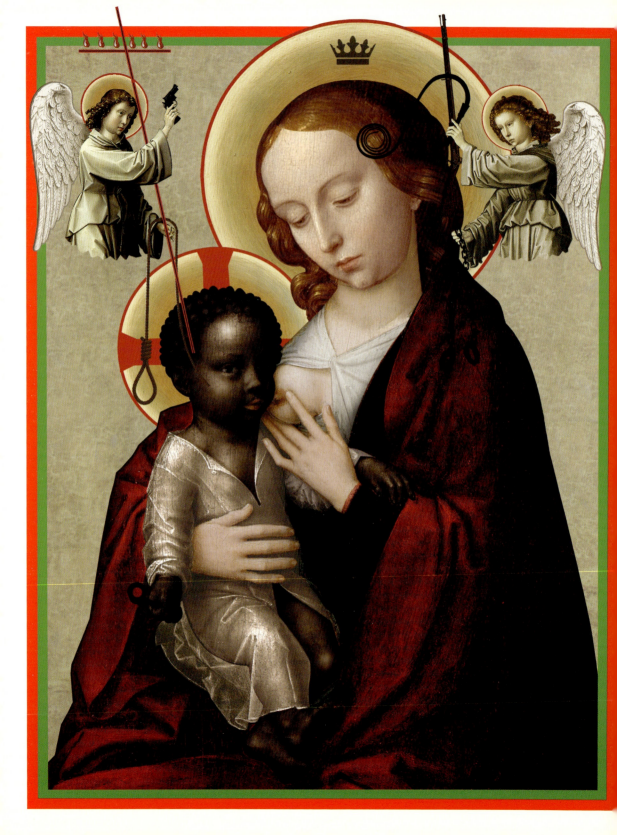

The Song of the
N-Word of God

OPPOSITE PAGE: "The Rape of the Virgin Mother and The Instruments of African American Passion After The Madonna Lactans (Nursing Madonna) and The Kissing Case of Monroe, North Carolina, 1959."

Sometimes, in visions, the Sound of the N-Word of God appears in the following manner:

...NNNNNNNNNNNNNNNNNNNNNNNNN
NNNNNNNNNNNNNNNNNNNNNNNNNN
NNNNNNNNNNNNNNNNNNNNNNNNNN
NNNNNNNNNNNNNNNNNNNNNNNNNN
NNNNNNNNNNNNNNNNNNNNNNNNNN
NNNNNNNNNNNNNNNNNNNNNNNNNN
NNNNNNNNNNNNNNNNNNNNNNNNNN
NNNNNNNNNNNNNNNNNNNNNNNNNN
NNNNNNNNNNNNNNNNNNNNNNNNNN
NNNNNNNNNNNNNNNNNNNNNNNNNN
NNNNNNNNNNNNNNNNNNNNNNNNNN
NNNNNNNNNNNNNNNNNNNNNNNNNN
NNNNNNNNNNNNNNNNNNNNNNNNNN
NNNNNNNNNNNNNNNNNNNNNNNNNN
NNNNNNNNNNNNNNNNNNNNNNNNNN
NNNNNNNNNNNNNNNNNNNNNNNNNN
NNNNNNNNNNNNNNNNNNNNNNNNNN
NNNNNNNNNNNNNNNNNNNNNNNNNN
NNNNNNNNNNNNNNNNNNNNNNNNNN
NNNNNNNNNNNNNNNNNNNNNNNNNN
NNNNNNNNNNNNNNNNNNNNNNNNNN
NNNNNNNNNNNNNNNNNNNNNNNNNN
NNNNNNNNNNNNNNNNNNNNNNNNNN
NNNNNNNNNNNNNNNNNNNNNNNNN...

This pattern is the symbol and the song of the N-Word of God. It is light (white) and vibration (sound). It inhibits blackness, with only one letter (N) being needed to spell it and a sequence of that one letter required to describe its sound. For the sound is heard in the cadence of repeating that single beat…the letter N — *one N after another.*

The ellipsis (three dots) before the cadence indicates no apparent beginning. The ellipsis (three dots) afterward indicates that it has no foreseeable end.

Now, try to pronounce it, and you will hear the cadence's sound. Yet, beware, for the sound is known to drive those of Black-kind who listen to it without ceasing and without understanding… to madness.

So, therefore, at an appointed time, the Uncreated Light of the ENIGGERMA, even Saint Sambo, the embodiment of Our Wisdom, came to teach those that would be Wise.

...NNNNNNNNNNNNNNNNNNNNNNNNNNNNN
NNNNNNNNNNNNNNNNNNNNNNNNNNNNNN
NNNNNNNNNNNNNNNNNNNNNNNNNNNNNN
NNNNNNNNNNNNNNNNNNNNNNNNNNNNNN
NNNNNNNNNNNNNNNNNNNNNNNNNNNNNN
NNNNNNNNNNNNNNNNNNNNNNNNNNNNNN
NNNNNNNNNNNNNNNNNNNNNNNNNNNNNN
NNNNNNNNNNNNNNNNNNNNNNNNNNNNNN
NNNNNNNNNNNNNNNNNNNNNNNNNNNNNN
NNNNNNNNNNNNNNNNNNNNNNNNNNNNNN
NNNNNNNNNNNNNNNNNNNNNNNNNNNNNN
NNNNNNNNNNNNNNNNNNNNNNNNNNNNNN
NNNNNNNNNNNNNNNNNNNNNNNNNNNNNN
NNNNNNNNNNNNNNNNNNNNNNNNNNNNNN
NNNNNNNNNNNNNNNNNNNNNNNNNNNNNN
NNNNNNNNNNNNNNNNNNNNNNNNNNNNNN
NNNNNNNNNNNNNNNNNNNNNNNNNNNNNN
NNNNNNNNNNNNNNNNNNNNNNNNNNNNNN
NNNNNNNNNNNNNNNNNNNNNNNNNNNNNN
NNNNNNNNNNNNNNNNNNNNNNNNNNNNNN
NNNNNNNNNNNNNNNNNNNNNNNNNNNNNN
NNNNNNNNNNNNNNNNNNNNNNNNNNNNNN
NNNNNNNNNNNNNNNNNNNNNNNNNNNNNN
NNNNNNNNNNNNNNNNNNNNNNNNNNNNNN
NNNNNNNNNNNNNNNNNNNNNNNNNNNN...

And what is this wisdom that he taught?

The wisdom that he taught the Black and the Wise **was to lay the N-Word of God down!** (Such simple brilliance!)

And when the very wise, through this wisdom, laid it down, **the Song of the N-Word of God was transformed.**

And in its transformed state, it appeared the way you see it depicted here, displaying the very symbol of cartoon rest!

Note that this symbol of rest can be disturbing to others standing by who are either becoming or are woke. (However, those that are embraced by the symbol's deep slumber — hear nothing at all.)

...ZZ
ZZZ
ZZZ
ZZZ
ZZZ
ZZZ
ZZZ
ZZZ
ZZZ
ZZZ
ZZZ
ZZZ
ZZZ
ZZZ
ZZZ
ZZZ
ZZZ
ZZZ
ZZZ
ZZZ
ZZZ
ZZZ
ZZZ...

This is the very same rest of the Wise and the Black that have gone before us!

For they knew that pure contemplation of the **ENIGGERMA** of their Existence was too hard to endure and too difficult for any Black soul to bear without, from time to time, ceasing from thinking about it and now and then, not hearing the dreadful hum of its N-Word.

And these same Wise and Black folk also knew this unfortunate truth — that it is hard to love White people and be awake simultaneously. Amen?

Yet, it is an excellent feat to do both (if you can).

Because to do both is highly beneficial. For being awake around White people can be annoying to them. And "the not loving" of White people can be dangerous for us.

(This the ancestors also well knew.)

```
...ZZZZZZZZZZZZZZZZZZZZZZZZZZZZZZZZZZZZZZZZZZZZZZZ
ZZZZZZZZZZZZZZZZZZZZZZZZZZZZZZZZZZZZZZZZZZZZZZZZZ
ZZZZZZZZZZZZZZZZZZZZZZZZZZZZZZZZZZZZZZZZZZZZZZZZZ
ZZZZZZZZZZZZZZZZZZZZZZZZZZZZZZZZZZZZZZZZZZZZZZZZZ
ZZZZZZZZZZZZZZZZZZZZZZZZZZZZZZZZZZZZZZZZZZZZZZZZZ
ZZZZZZZZZZZZZZZZZZZZZZZZZZZZZZZZZZZZZZZZZZZZZZZZZ
ZZZZZZZZZZZZZZZZZZZZZZZZZZZZZZZZZZZZZZZZZZZZZZZZZ
ZZZZZZZZZZZZZZZZZZZZZZZZZZZZZZZZZZZZZZZZZZZZZZZZZ
ZZZZZZZZZZZZZZZZZZZZZZZZZZZZZZZZZZZZZZZZZZZZZZZZZ
ZZZZZZZZZZZZZZZZZZZZZZZZZZZZZZZZZZZZZZZZZZZZZZZZZ
ZZZZZZZZZZZZZZZZZZZZZZZZZZZZZZZZZZZZZZZZZZZZZZZZZ
ZZZZZZZZZZZZZZZZZZZZZZZZZZZZZZZZZZZZZZZZZZZZZZZZZ
ZZZZZZZZZZZZZZZZZZZZZZZZZZZZZZZZZZZZZZZZZZZZZZZZZ
ZZZZZZZZZZZZZZZZZZZZZZZZZZZZZZZZZZZZZZZZZZZZZZZZZ
ZZZZZZZZZZZZZZZZZZZZZZZZZZZZZZZZZZZZZZZZZZZZZZZZZ
ZZZZZZZZZZZZZZZZZZZZZZZZZZZZZZZZZZZZZZZZZZZZZZZZZ
ZZZZZZZZZZZZZZZZZZZZZZZZZZZZZZZZZZZZZZZZZZZZZZZZZ
ZZZZZZZZZZZZZZZZZZZZZZZZZZZZZZZZZZZZZZZZZZZZZZZZZ
ZZZZZZZZZZZZZZZZZZZZZZZZZZZZZZZZZZZZZZZZZZZZZZZZZ
ZZZZZZZZZZZZZZZZZZZZZZZZZZZZZZZZZZZZZZZZZZZZZZZZZ
ZZZZZZZZZZZZZZZZZZZZZZZZZZZZZZZZZZZZZZZZZZZZZZZZ...
```

And these Wise and Black ones knew that anger and hatred exacerbate Black foolishness, and the reasons for this are simple.

For how can you successfully go up against tanks, bazookas, and the A-bomb with shotguns and black berets? So, the Wise and the Black sought this curious sabbath, this sly rest, this tricky spiritual peace, this complicated compassion, this **Shine**, to increase their virtue, desirability, prospects, and mental health — and many of their own kind, in error, labeled these wisely accommodating ones as 'Uncle Toms.'

However, these Wise ones merely exhibited a high wisdom and demonstrated how best an excellent survival virtue may be attained and expressed.

For is it not written, "Come ye that are weary and heavy-laden, and I will give thee rest"? And did not Jesus say to forgive?

…But I say unto you: "Forget." (This is what Saint Sambo has taught us.)

For forgetfulness is better than forgiveness and is the more perfect and sure way not to be offended and not to offend.

Glory be!

For they that have forgotten need not to forgive anything for they remember naught of the past and little of the present.

Such divine ignorance is sweet nothingness and is 'wholly, holy, holey.' (You will understand more later.)

And this is why with our heads where the "Sun Does Not Shine," we paradoxically yet see a great light!

This is the same light of the White (Sun/Son) of God (both *S-U-N* and *S-O-N*), and through it, we find inner peace of splendid worth. Even a peace that surpasses all knowledge (for we know nothing) and all understanding (for we have forgotten everything), and therefore, we do not see that anything has been done at all (to us), and therefore, there is no room for an offense to be found…in any way. (This Cloud of Unknowing is extraordinarily effective and attracts much popular White American favor.)

And we are granted this attainment not by the Word of God but the glorious N-Word of God as if cordially being invited to enter a White person's house through their backdoor.

And those that are allowed to enter therein have attained Great Virtue, even Great Whiteousness and Grace, and they are divinely protected from certain snares and pitfalls found in the ENIGGERMA.

For instance, if we forget we have civil and human rights when stopped by the police, we will not be tempted (out of pride) to remind them of these rights or get angry or upset, and we will peacefully comply in every manner out of fear and respect.

The police, in return, will not get angry with us, or be puffed up and try to kill us to show us the truth and afterward say that they feared for their lives because we did not comply and do as they ordered.

Does this not make perfect sense, O' Wise ones?

You see, Saint Sambo has great wisdom for us. It is he that has said, "White words (laws) on white paper cannot be easily seen or read even in daylight and are meaningless to Black-kind in the dark times of great American crises where charismatic responses are required to keep body and soul together before the instant might and the reprisal of White."

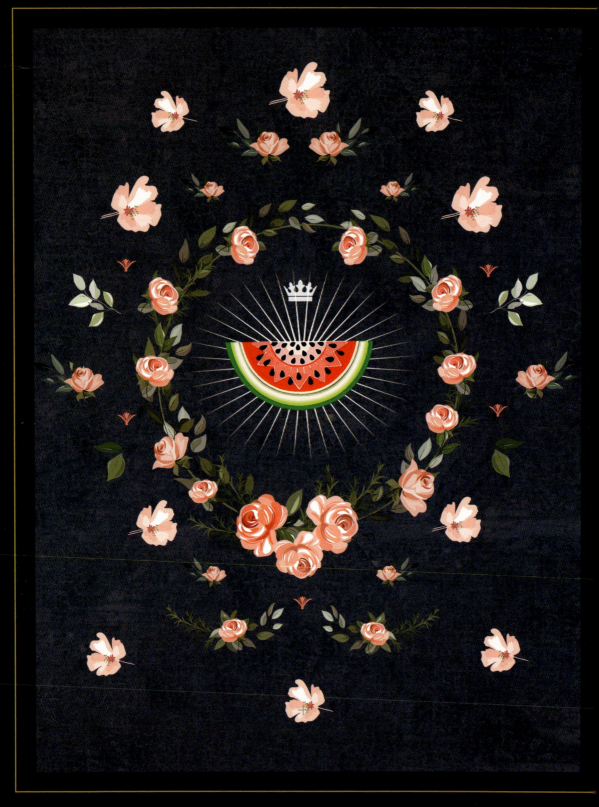

BOOK TWO

The First and Second Apocalypse of Ain't Jah's Momma of God

The Annunciation: (Or 1st Apocalypse of Ain't Jah's Momma of God)

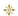

The Divine Economy: (Or 2nd Apocalypse of Ain't Jah's Momma of God)

The Annunciation:
(Or 1st Apocalypse of Ain't Jah's Momma of God)

OPPOSITE PAGE: *Our Lady of the Apoc-a-Lips and Watching Miz' Rosemary's Baby."*

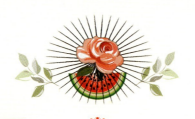

Now the birth of Saint Sambo was on this wise.

In due time, an angel in the form of the Statue of Liberty came to his mother, who was at that time called Aunt Jemima. The angel was very courteous to her, greeted her, and said, "Hello! You are highly favored! For now, light has come to 'darkyness.' And you shall conceive a child.

"For behold, a virgin shall be with child and shall bring forth a son, and he shall be mighty in the ways of Whiteousness."

Then Aunt Jemima said to the angel, "How cums does yah caw me a virgin? Seein' dat ah hab bin knowns by a man."

OPPOSITE PAGE: *"The Annunciation of Aunt Jemima/Aint Jah's Momma of God. Pt. 1 (The Greeting)."*

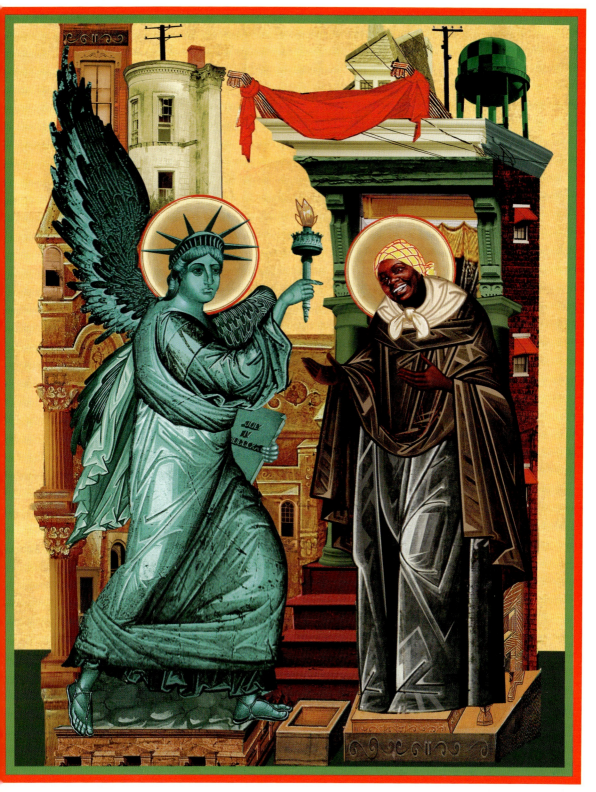

Now, the angel answered and said to her. "You are mistaken. For he that has been with you and has known you has been legally considered in the past by the Supreme Court of the Land to be only three-fifths a man and therefore also he has been widely called a 'boy.'"

(And the angel said this about the blessed Uncle Tom who had a cabin where Aunt Jemima lived with him in the manner of a husband and of a wife.)

"Therefore," the angel said, "the Spirit of the Kosmic Koon Khrist shall come upon you, and the uncreated light of the N-Word of God shall enter your womb.

OPPOSITE PAGE: *"The Annunciation of Aunt Jemima/Aint Jah's Momma of God. Pt. 2 (The Uncreated Light of the ENIGGERMA Entering Aunt Jemima's Womb)."*

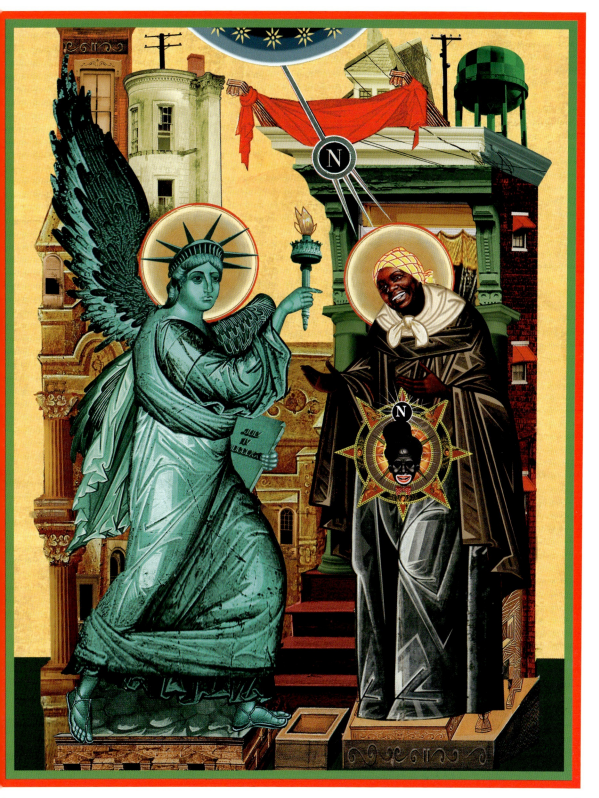

"And therefore, that thing which shall be born of you shall be called "Anonymous and Saint" for he shall be mysterious and a speaker, even a doer, and a revealer of a holy salvation.

"A salvation found only in the Wisdom and Whiteousness of the N-Word of God. And he will be called the Light of the ENIGGERMA."

Aunt Jemima said, "Dat sounds good! Behol' me! The handmaid of da Lawd! Let it be to me in accords to yer N-Word." Then Aunt Jemima said to the angel, "May I ass you a question? Kine sah, what is da ENIGGERMA? Pleez answer me for I wonder about it."

The angel said, "That is good that you wonder about it, for it is something to wonder about.

"You see, the word ENIGGERMA is a portmanteau. A portmanteau is a word that is a blend of separate words, a blend of both their spelling and their meaning. In this case, the two words are 'enigma' and 'nigger.'"

The angel went on. "Oh, Negress of Great Goodness! Therefore, '*ENIGGERMA*' is a special kind of mystery that pervades all things Black in America. The great mystery of Black life transverses the four dimensions of Black American existence.

"These different dimensions of Black American existence are America, AmeriKKKa, Americoonia, and AmeriKKK-coonia. And these dimensions are intimately connected to the existence of an all-powerful and White God worshipped in all of these lands."

Then Aunt Jemima asked, "Is da bo' stan'ards a part of da ENIGGERMA? I hab been wondering about this too."

The angel replied, "Yes, it is. Double standards are its single most significant attribute, but denial, lying, alt-facts, post-truth, and confusion are all its hallmarks. That is why the ENIGGERMA is so damnably eniggermatic.

"Like, for instance, is it not written, 'that all men are created equal?' But, at the same time, Black 'men' were considered the property of White men. And this is OK. (And it is OK why? It is OK because it is…an *eniggerma*.) Justification for anything can be found in the N-Word. Do you understand?

"For instance, is it not sung and written that America is 'the land of the free and the home of the brave'? But at the same time, for the Black-kind, the reality was 'the land of the free and home of the slave.'

"How can America be 'the land of the free and home of the slave' at the same time? That's not an enigma. That's just an 'eniggerma.' You see how when we add the N-Word, pertinent knowledge is also increased?

"For instance, is it not said, 'All Lives Matter' in response to 'Black Lives Matter' being spoken when a White cop takes another unarmed Black life?

"This is not a riddle, nor a puzzle, nor an enigma. (Yes, I think you are starting to understand.) *This is an 'eniggerma'* and part of the greater mystery of the *grand* ENIGGERMA of Black Existence itself. Those of the Black-kind that understand this understand much. And they are not easily killed."

Aunt Jemima said, "You no a lot." And she asked the angel, "What does this all-powerful White God look lik'? I want to see Him in His glory so I can better worship Him."

The angel said, "Wonderful! That is good!"

Then the angel pointed upward and said, "Look!" and Aunt Jemima looked. The sky opened up, and Aunt Jemima saw an incredible sight.

Aunt Jemima saw a White man in the highest heaven, sitting upon the highest throne. He was dressed in glorious raiment, and he had a white beard.

His feet were surrounded by mist and lightning, and the earth was his footstool, for he was full of power, glory, and had authority; and in his lap, there was a curious work being done.

The angel that spoke to her said, "Behold the powerful White God! Behold a vision of that which you and all Black-kind in America have been taught to love and to fear — even if many of you consciously deny it, to keep your Christian faith and hope alive.

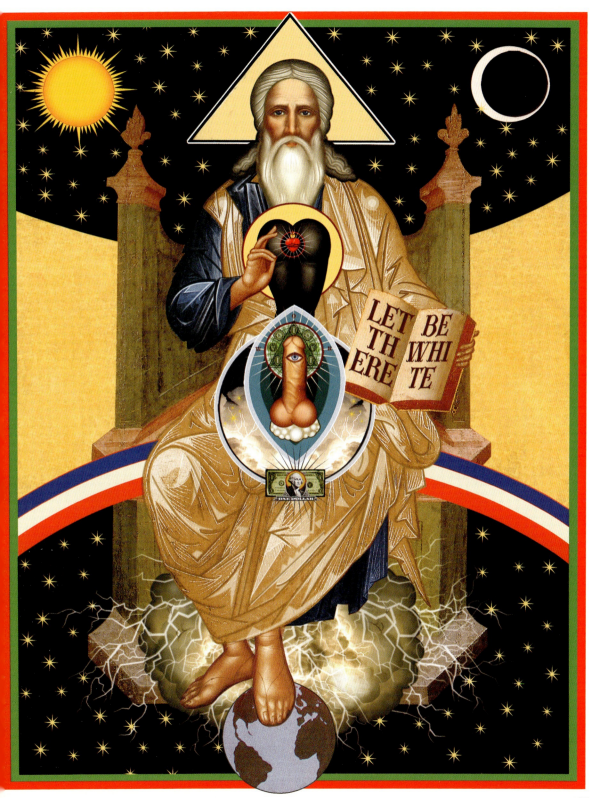

"For has not this White God allowed White people to rule over you because they are made in his European image and thus His grand whiteness? Has this not been whispered repeatedly into your Black consciousness throughout your American generations?"

And the angel spoke sweetly.

"For, Negress of Great Goodness and Excellent Pancakes, isn't it understood in the very fabric of this great society that God's form is made perfect through European WHITENESS and LIGHTNESS and not through African BLACKNESS and DARKNESS?

"And doesn't this mean that in the preference of WHITENESS and LIGHTNESS that this now necessarily White God must logically know in a biblical sense a Black Rear of the World that he has created? For has he not created all things and/or allowed them to be as they are?

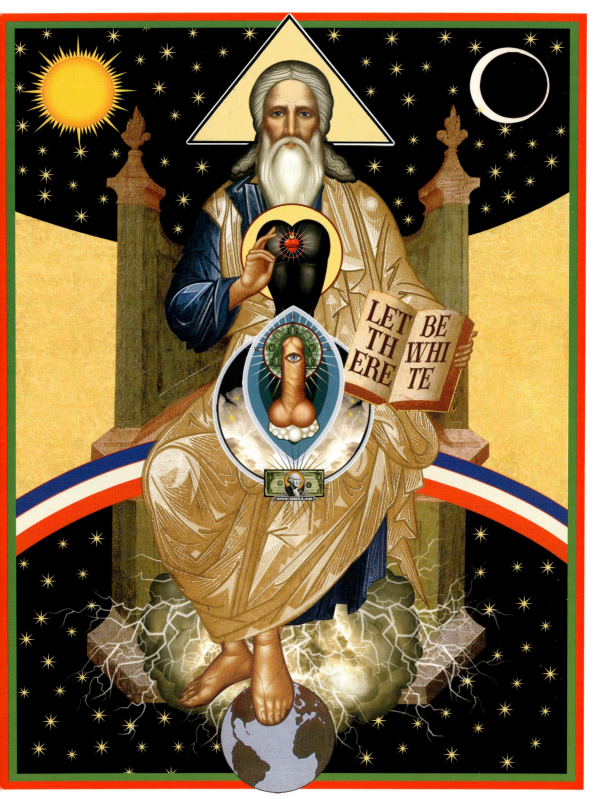

"Why are you so upset and surprised at this image of God, my Dear one?" (He said this, for he heard Aunt Jemima exclaim loudly upon first seeing the vision, "Oh, my God!")...and the angel continued.

"This vision is only logical and rational. And is this vision not rooted in the basis of the **ENIGGERMA** of Black American Existence that you already perceive?" he said.

"But be patient, highly favored one. There are many mysteries to be known, and I still have more things to show you. For instance, now I will show you the future of your great son and the most intimate revelation of this White God.

"Look!" the angel said. And Aunt Jemima looked, and she saw another vision. This time it was of her son, who was fully grown, and he was by a house, and a mysterious woman was there with him.

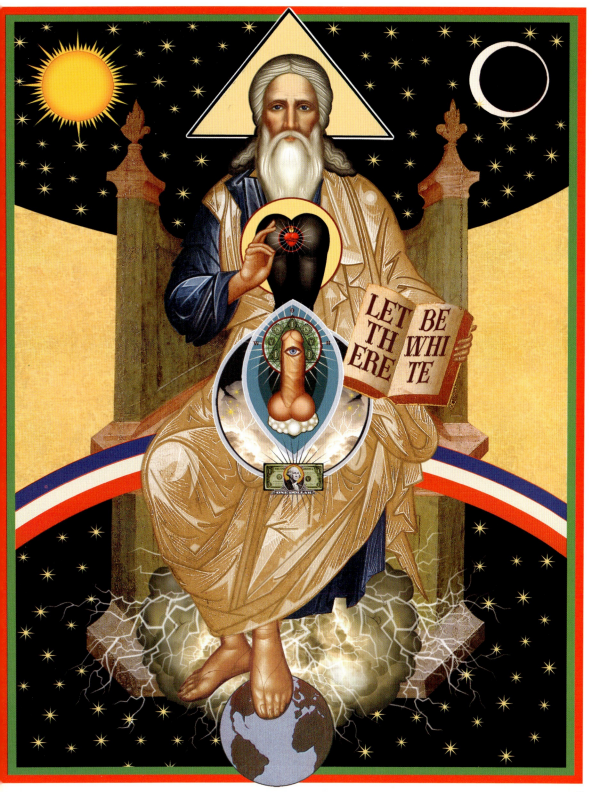

The angel announced: "There will come a time in the future that your son will set out upon a journey into the wilderness. He will do this after speaking to a mysterious woman who is both equally Black and White simultaneously.

"*You see, he entertained the angel of the ENIGGERMA unaware.* And she will speak to his heart about grave matters and the deep things of Black life that he has been pondering since he was a child.

"She will tell him to go to what will be known as Revelation Mount in the future. She says there is a strange fruit that is pleasing to the eye, sweet in the mouth, bitter in the belly, and desirable for great wisdom there.

"And with her comes the Maw of Hell and the chains of those spiritually and mentally bound by the confusion inherent in the maze-like ENIGGERMA of their existence.

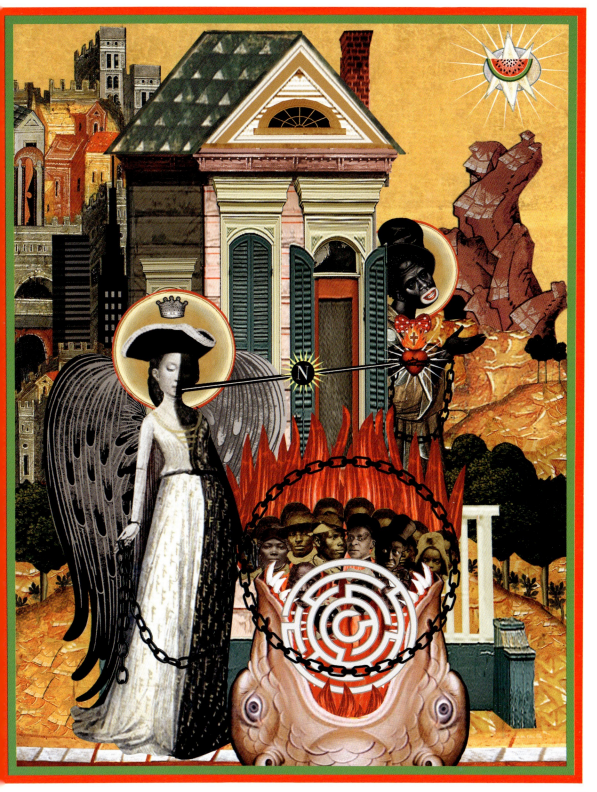

"And she tells him that afterward he will be endowed with power and set many mentally and spiritually free.

"And this angel of the ENIGGERMA will travel with him on his journey even to the very foot of Revelation Mount and only then depart from him at that time.

"And by himself, your son will climb to the top of the mount and receive many revelations. The first is the Revelation of the Sacred Fruit, even the Divine Grin of Grace, the Very Foundation of Whiteousness, and of True Knowledge, Peace, and Power.

"And that fruit shall not depart from him from henceforth.

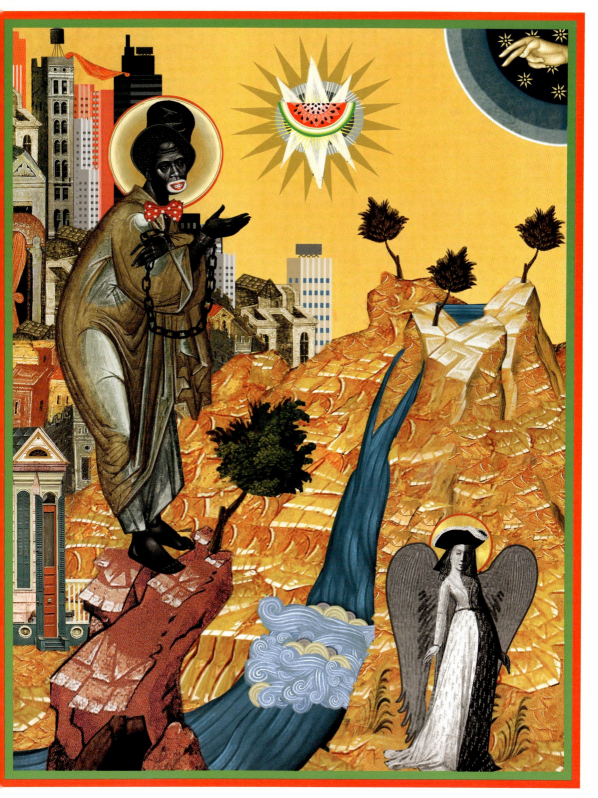

"Now, after partaking of the Sacred Fruit, your son shall have a vision of true holiness, even that of the Divine White Booty of God Itself (*which is the very same rear of the God you saw previously*).

"And your son shall hear a voice from heaven telling him to prepare for a further revelation of this Divine White Booty of God. (This revelation is hidden from his view in the icon on the opposite page and is behind crucified and divine white hands in this depiction.) Note: this further revelation is the greatest and *most intimate* revelation of all!"

(And if your senses are keen, you can tell that Saint Sambo is inwardly preparing himself to be astonished.)

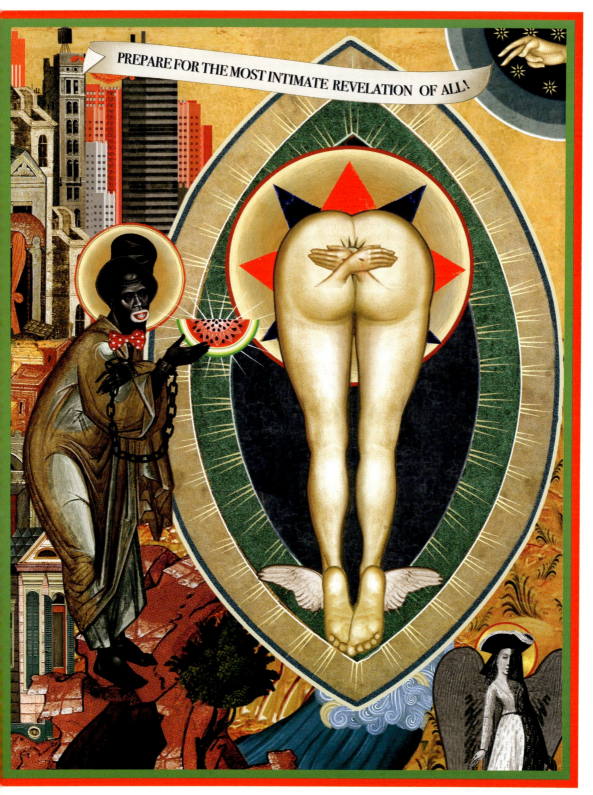

"*This further revelation of the Divine White Booty of God,* even the most awesome and the *most intimate* revelation of all…is now revealed by an unobstructed view to be the *Ass Holy of Holy* **and** *that smiling curious thing which is inside of it.*

And what is that smiling and curious thing which is inside the *Ass Holy of Holy?*

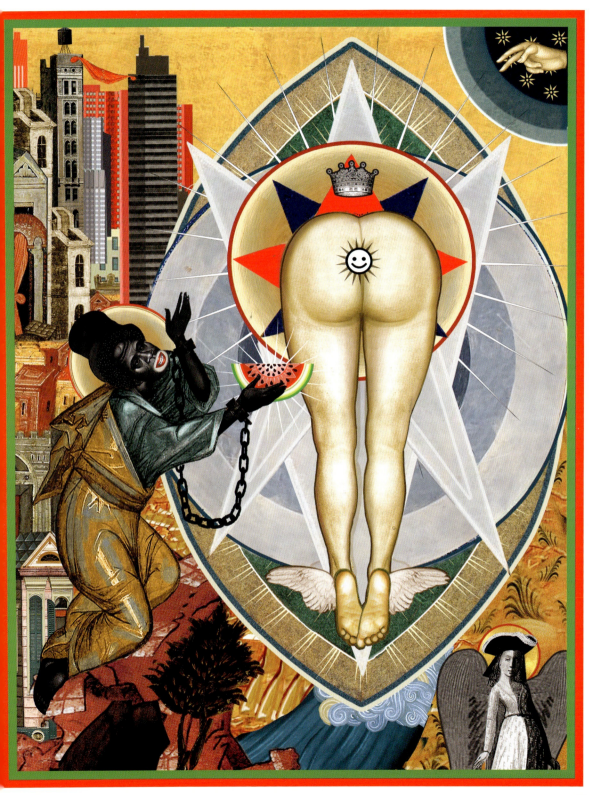

"Of course, it is the ever-happy face of White privilege."

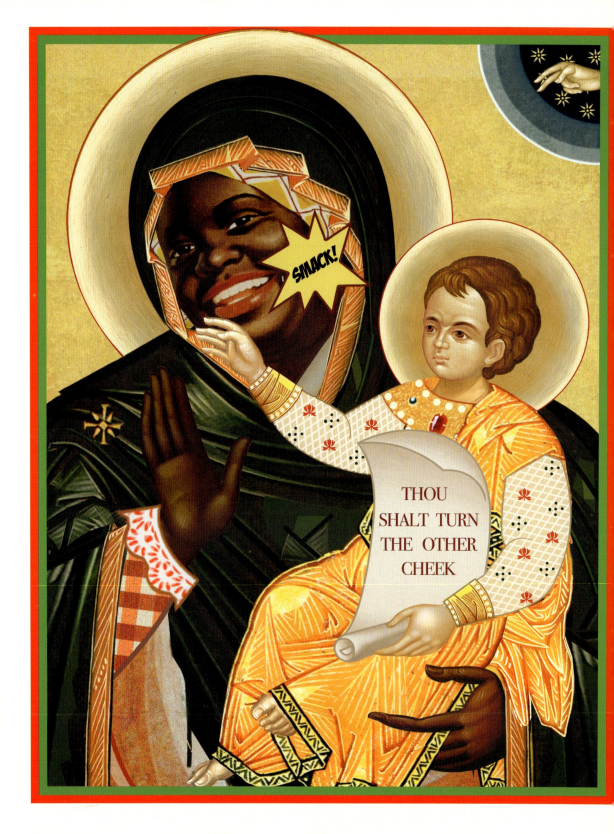

The Divine Economy:
(Or 2nd Apocalypse of Ain't Jah's Momma of God)

OPPOSITE PAGE: *"Ain't Jah's Momma of God and White Baby Jesus Presenting His Social Justice and Racial Equality Program to the Nation."*

Now, the angel said, "As of this moment, your name will not be Aunt Jemima any longer. But from henceforth, you shall be known as Ain't Jah's Momma, and many will honor you and respect you and will call you by your full name and title, even Ain't Jah's Momma of God." And then he departed.

And so, and in accordance to the word spoken by the angel that visited her, in due time, Ain't Jah's Momma of God conceived and gave birth to a manchild at the appointed time.

And he was Black as coal and had the most beautiful smile, even from birth.

And always he could be found smiling. And, of course, this was Saint Sambo, but his given name was Anon Amos. Because the angel said he would be called Anonymous and Great Saint. And Ain't Jah's Momma of God misunderstood the angel and what he meant by "Anonymous" — and that people would not really know who he was. So she called her child Anon Amos.

You see, "Saint Sambo" was merely a nickname that caught on early in Saint Sambo's ministry because of his brilliant smile, jet-black skin, and his penchant for wearing robes and preaching the Whiteousness of God.

Now, there were many things that the angel of the Annunciation didn't have time to reveal to Ain't Jah's Momma of God.

For instance, he did not tell her of Saint Sambo's other visions that he received on Revelation Mount. But for your benefit and edification, I will now tell you about four crucial visions of the Divine Economy that Saint Sambo received.

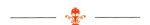

Behold the first vision! Also, make a note of the shining penny (which is brown and of the lowest denomination of currency and has on it the image of the Great Emancipator). This penny represents necessary sustenance, and when landing in the middle of the attractive Black palm, it makes a mark.

This mark is called the *Stigmata of the Coon Christ.* It is a mark of great distinction. For money in America grants great distinction. And it is a mark of very life and very death. Because without slavery, you can't keep body and soul together without money.

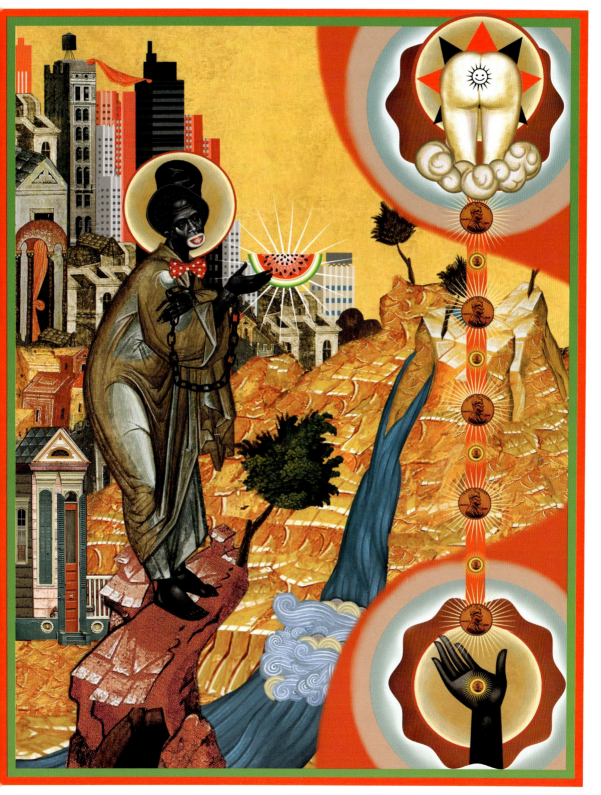

Behold! The second vision and it is called "*The Closed Fist of Black Power.*" It is appropriately titled, for is not the sign of Black power a closed Black fist?

And "*The Closed Fist of Black Power*" is opposed to "*The Stigmata of the Coon Christ*" for it disputes the efficacy of whiteousness. This is unfortunate. For we can clearly see in the vision: a closed Black hand can not give to others, and moreover, a Black fist can not RECEIVE that which would grant a stigmata of great value.

And observe! Look above, and you will see the truth. For the Smiley Face in the Ass Holy of Holy is grieved.

Woe.

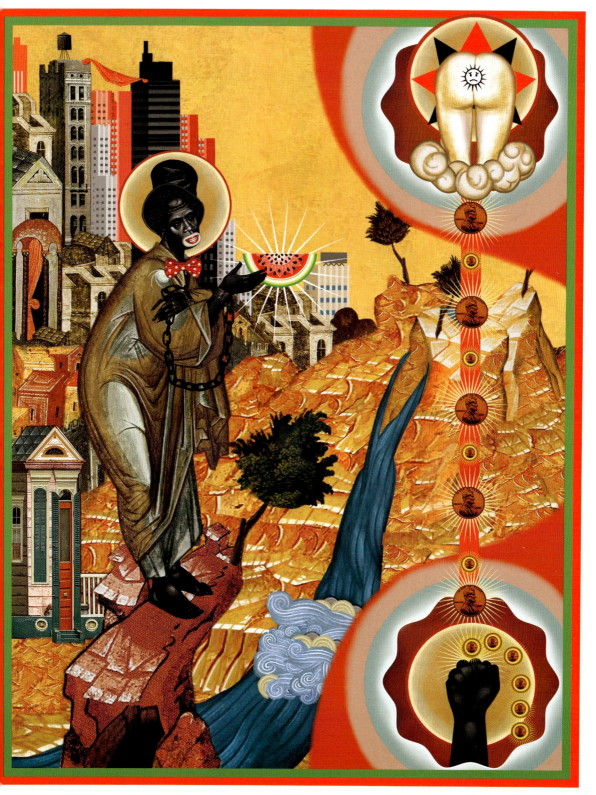

Now, we come to the third vision of this series, which is simultaneously the height of divine disrespect and Black foolishness (according to the laws of Whiteouseness).

And we even see the dire consequences thereof.

Behold, the Ass Holy of Holy has puckered up! No earthly or divine blessing is flowing! For the Divine White Booty of God is now withholding the grace necessary to keep Black body and soul together because of aversion to such disrespect and rebellion as seen in giving the finger to the **White Rear of GOD!** My! My! My! My! And therefore, there is division, a great gulf between it and they, and a curse.

The fourth revelation in this series of visions is seen here. Consistent with the complexities inherent in the ENIGGERMA — is the existence of Black financial success. Black financial success can be seen as problematic; the Black-kind with such success might incur White envy and labeled as being uppity and not knowing their place, and such success might be seen as a revolutionary act of pseudo-independence.

Remember Black Wall Street.

Black eyewitnesses accounted that dynamite or Molotov cocktails were used upon the district of Greenwood and thrown from airplanes flying overhead during the Tulsa massacre. Many White scholars discount this.

But this we know. We know money is power. And Black money is Black power. As Saint Sambo has said, "Is it not written that, 'The love of money is the root of all evil'? But I say unto you — Is not the lack of money the root of much Black evil also?"

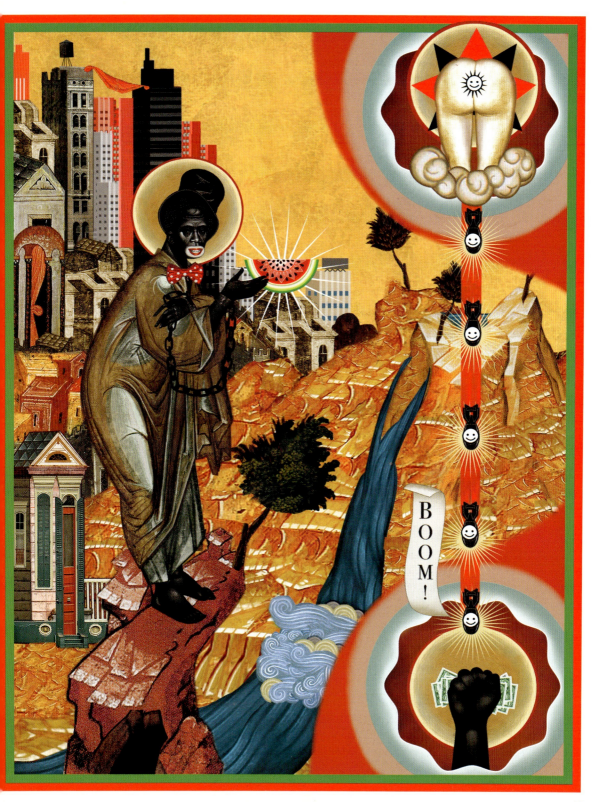

BOOK THREE

The Gospel of Saint Sambo

———— ————

Saint Sambo and the Ten Brothas of Ill Intent

The Sermon on the Dumpster

The Plantation of the Present World

The Burning Cross of Liberty

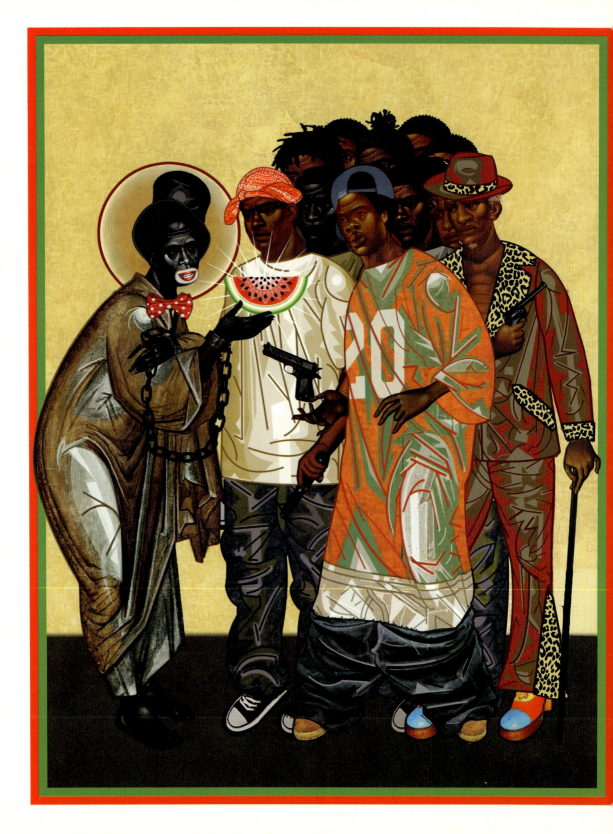

Saint Sambo and the Ten Brothas of Ill Intent

OPPOSITE PAGE: *"Saint Sambo's Confrontation with the Ten Brothas of Ill Intent."*

There came a time after his journey to Revelation Mount and having visions when it was time for Saint Sambo to present himself and preach to the world.

So straight away, Saint Sambo went about the city, raising his voice and saying, "The Plantation of God is here!"

He taught on the ways of Whiteousness; some received his great wisdom well, and many were compelled to consider the truth of his word. Some believed him, and some did not. After a specific time, he became more known and even started to become great.

At this time, Saint Sambo met Ten Brothas while traveling from here and from there and preaching the good news of the Plantation of God, as was his want and his burden.

And upon seeing them, Saint Sambo said, "Greetings, brothers! A piece be unto you!" And he offered them a slice of the sacred fruit, even the shining watermelon he always had with him.

And many of the Ten Brothas raised a hand above their head, and in each hand they raised, there was a gun.

"We do not need your piece, Saint Sambo," they said, "for each and every one of us has our own piece. Ha! Ha! Ha! Ha! And we like ours just fine, thank you very much! Ha! Ha! Ha! Ha!"

Saint Sambo said, "I perceive that you are Ten Brothas of Ill Intent."

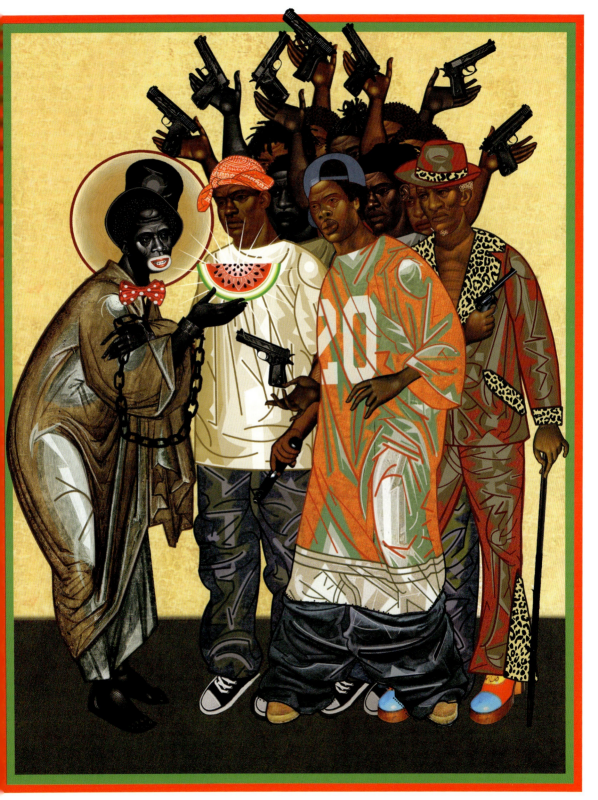

And they replied, "Yes, we be bad! Ha! Ha! Ha! Ha! And cool as hell! We be gang members, even ballers, dope dealers, and thugs, and we even call each other dawgs. Moreover, we consider ourselves players in the great game of life.

"And every one of us has taken a vow to neither eat nor sleep until you are six feet under and dead. For we perceive and know what you really are and that you are a grinning, cheese-eating, and White-ass-kissing Negro, and the doctrine you teach we cannot stand."

And Saint Sambo said, "You think you know, but you know not as you ought, but I know fully of what I do. Now, the wisdom that I teach has come down from our ancestors who endured much suffering, and from them comes the word I preach, and it is older than your hip hop and more enduring than your thug life.

"For, verily, I say unto you, when the ancestors were still on the plantation and in slavery so-called and were first introduced to the veneration of the Divine White Booty of God and were diligently taught it even at the tip of the master's whip, I was there. Now, I come a-preaching that which I know endures and what only I have experienced in its fullness."

And the Ten Brothas were surprised at his words, and they began to laugh.

"Oh! My! My! My! Check old 'G' out!" They said to themselves. "Isn't he one off-the-hook motherfucka, and crazier than hell?"

Then they said to him, "Tell us this, you crazy-ass motherfucka, you! How can you have lived with the ancestors during slavery? Nobody living can be that old."

Saint Sambo looked at them, smiled, and said, "Verily, I say unto you before Harriet Tubman, Sojourner Truth, Frederick Douglass, and even Kunta Kinte was, **I IS**."

Now, at this, the Ten Brothas became upset and rent their garments, and because many of them were dropouts, they said, "Harriet Tubman, we know not. Sojourner Truth, we know not. Fredrick Douglass, we know not. And Kunta Kinte, we know, for we saw *Roots* on TV.

"And this we know also, that Saint Sambo, to us you ain't no saint. We don't recognize you, for you badmouth our gods and disrespect our pimps and preachers. You talk as if we live still in the past, and we all should be good coons and good niggers.

"But we all say, '**Fuck that shit!**' and that we be not coons and we be not niggers, but we be *cool*, and we be *niggahz*. (And yes, we proudly use that term.)

"As one of our very own prophets has spoken, 'A nigger is a Black man with a white rope around his neck, and he is hanging from a tree. A niggah is a Black man with gold chains around his neck hanging out at the club.'*

"And now, you would have Black people go backward rather than go forward. To continue to worship the Divine White Booty of God and revere it as has been taught to us of old?

"Therefore, we have decided to do a good deed. We have decided that we shall rid our people from the likes of you. Now, Saint Sambo, be prepared to meet your maker! For we are now going to bust a cap all up in your ass! And we are planning not to pop just one up there but quite a few!"

*Tupac Shakur

Saint Sambo said, "Wait! My brothers!" And he stepped up on a high place called a dumpster so that he might be more clearly seen, and from up there, he opened wide his arms and he said, "Now, I am ready. And I say, go on and do what you think you must do. But I forewarn you that no weapon you have formed against me will prosper for, verily, I say unto you, ***I am the N-Word of God***!"

This drove the Ten Brothas even more crazy for this truth they did not understand, and they became totally beside themselves in anger.

"Fuck you! You crazy-ass niggah!" they said. "How dare you talk to us like that?"

They then joked among themselves and their leader said, "He acts as if he has some kind of power that will protect him from the likes of us!"

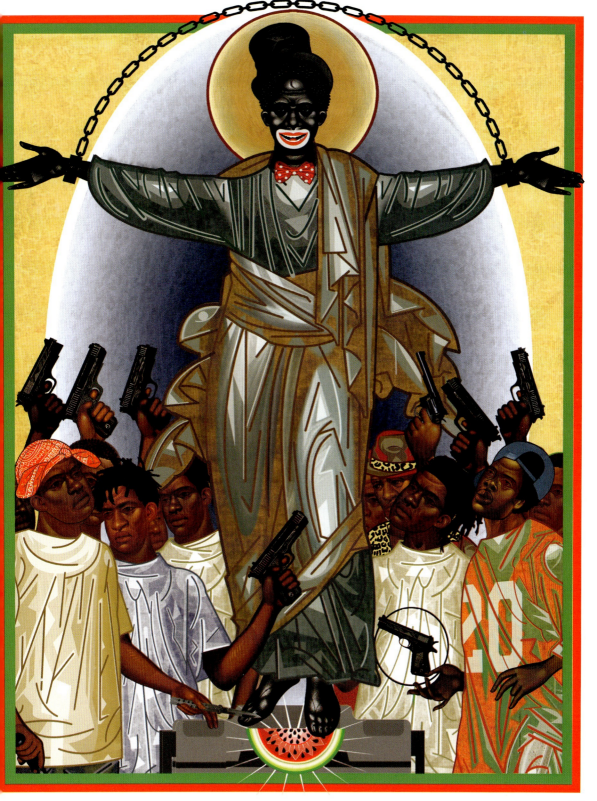

They then pointed their guns at Saint Sambo.

"Die, niggah! Die!" they said, and they proceeded to shoot at him! "Ha! Ha! Ha! Ha!" they laughed.

"Take that and that! And this and this!" they said.

Although they did not know it, they were in for a big surprise!

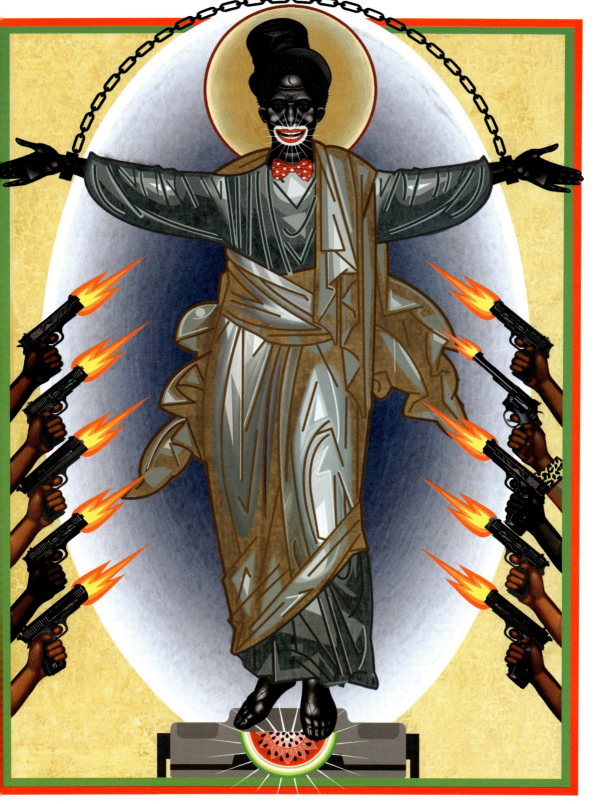

For they quickly found out they could not shoot Saint Sambo, **for he revealed to them at that time…the fullness of the Power of His Mighty Grin!**

And thereby Saint Sambo remained in their midst unharmed!

And they could not touch him.

For they could not see him.

For he was shining so brightly!

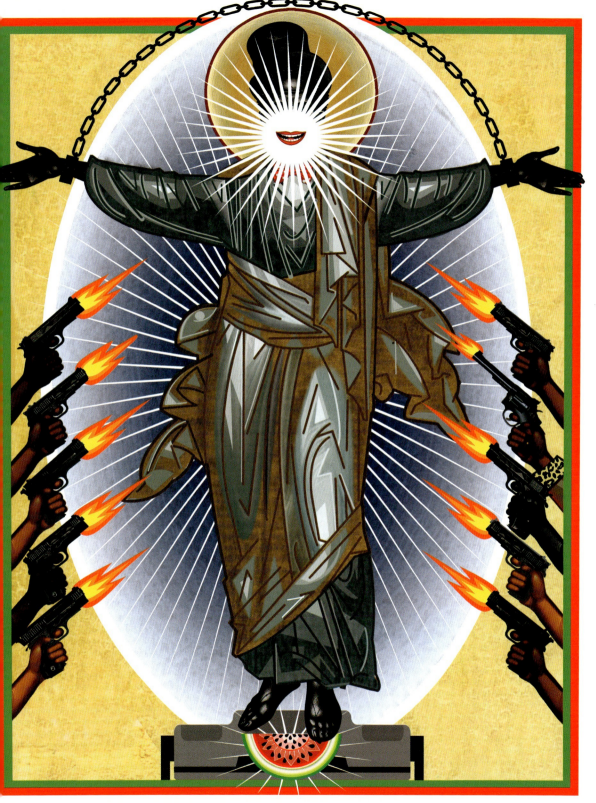

And the Ten Brothas of Ill Intent fell into confusion and in their confusion, they started shooting themselves instead!

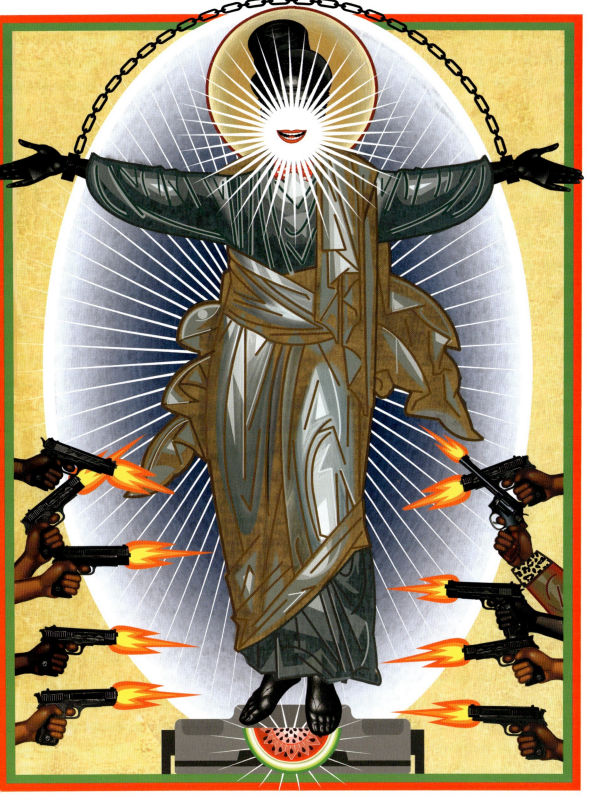

"Niggah, what you doing!"
"Can't you aim?"
"Damn! Motherfucka!"
"Don't point that at me!"

(Pow! Pow! Pow! Pow!)

"Aye! Shit!"
"Wait, Dawg!"
"Daaamn!"

They said.

And in no time at all, they all lay moaning on the ground, wounded unto death.

And the devil came and took their souls.

Then the crack-heads picked their pockets.

Saint Sambo wept.

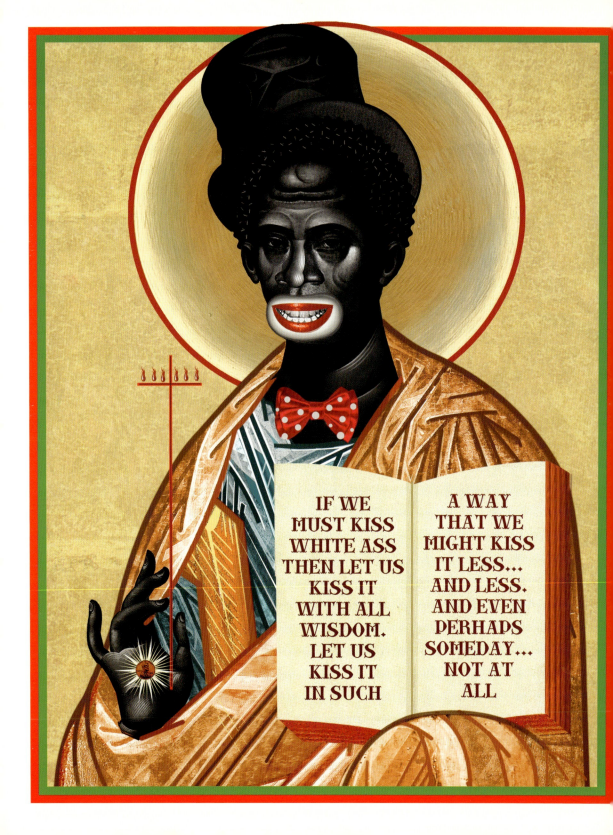

The Sermon on the Dumpster

OPPOSITE PAGE: *"Icon Portrait of Saint Sambo the Great, Prophet of Whiteousness, Coon Christ, Uncreated Light of the ENIGGERMA and Shine of the Whole World (with his Stigmata Displayed and Burning Cross)."*

The city people who had watched all that went on and witnessed the death of the Ten Brothas of Ill Intent were moved to sorrow. "Look how he loved them," they said. "He is weeping!" And they gathered around Saint Sambo.

Now, Saint Sambo looked around at them with compassion and still there at that high place called a dumpster he taught them, saying, "Now, the wise among you know that the traditions of the ancestors have been most fruitful regarding shining and putting on the watermelon grin.

"For verily, I say unto you, being 'bad' may seem cool, but those things that are cool, they are close to death. But where there is the grin of grace, there you shall find warmth, and you shall find life."

Saint Sambo smiled, and the crowd was dazzled by it.

"He that believes in the N-Word of God shall find fortune in odd places, even at a necktie party and amid a Klan meeting. Therefore, be wise as a serpent and always happy as a little boy. And remember that the dumb will always try to play smart, but the smart knows there are times when they must play dumb.

"And in all manner of supplications and prayers, let your petitions be known, but remember to pray in the proper position, which is on your knees and bent over. For the squeaky wheel gets the grease, but the black standing nail — gets hammered down.

"It is in your power today to choose heaven or hell, life or death, and you choose according to the corners of your lips. If they turn upward, you're heavenly bound. If they point downward, you are in a ghetto of hell and that of your own choosing. Amen!"

Many people wondered at his words and said, "We have never encountered someone who speaks like this. Who is he? And by what authority does he say these things?"

Then Saint Sambo cried out to the people, "What would I liken the Plantation of God to be like unto? I would liken the Plantation of God to be like unto a loaf of leavened bread that is sliced. And if you take the ends of it, you will know on what side they should be buttered on, for the side that is buttered is the side that is the lightest."

Then someone asked Saint Sambo, "I have heard some teach that God is really the color of water." (And by this, they meant that God was incorporeal and is spirit only.)

"What do you make of this, and is this the true teaching about God? And if this is the true teaching of God, shouldn't we forget about race for race doesn't matter and is an illusion?"

And Saint Sambo said, "Is there not Jesus who many of you consider to be God in the flesh and he had a body, did he not? And when you dream, does Jesus ever come to you as being Black without it being a statement about culture or race?

"Oh, ye of little understanding.

"Verily, I say unto you, there is Jesus, and there is Jes'U.S. and Jes'us and Jes'them. They are not the same. For behold, I show unto you a mystery — if you can bear it, and thus I say unto you, presently the Jesus that you have, is Jes'them or Jes'U.S. But, if you desire truth, Jes'us must be to you the true Jesus."

"WHAAAAT?" said the Christians among the mostly Black crowd, and they grew upset. They shouted, "We have heard others say many things about you. But now we know for ourselves that, you…Coon Christ — you are indeed a heretic and a blasphemer and most likely possessed by the devil!"

But there was an old wise man in the crowd, and he was well versed in the scriptures, and therefore he raised his voice and said, "Wait! Wait! Don't you see what Saint Sambo is saying?

"That only in niggerishness can the true Jesus be seen? For it is written of him in Isaiah, *'He had no form or comeliness; and when we shall see him, there is no beauty that we should desire him. He is despised and rejected of men; a man of sorrows and acquainted with grief: and they hid as it were their faces from him; he was despised, and they esteem him not.'*

"Now, if this is a description of Jesus as many of us have been taught, be we Black or White, and of the Christian faith," the wise man said, "this surely doesn't sound like a description of White superiority, White privilege or White empire, but like unto something else. Even like unto niggerishness in the life of Christ Jesus to me!" And when he said this, the spirit of truth came upon him, and right there, he had a vision and fell to the ground.

In this vision, he saw someone that looked very much like Saint Sambo, but this man was being given a white crown, and his hands were tied with white rope, and he wore a wooden coffin for pants. This person also spiritually dwelt in a prison strange beyond measure because that strange prison where he dwelt was a symbol of liberty to the whole world. And in his right hand he held the White Key of Black American Wisdom.

And a heavenly voice spoke to the wise man well versed in scripture and said, "Behold an image of Extreme Humility Called *Humbled-ness Itself and Pure Paradox of the Whiteous Mind.* Behold an Icon of the Land of the Free and the Home of the Slave and its Simultaneous Reality in Times Past. Behold Saint Sambo! Behold Jes'us Christ! Behold the Great AmeriKKKcoonian Passion Who Some in Derision Call Merely a Made-Up Pity Party for All the Darkies that Would be Kings!"

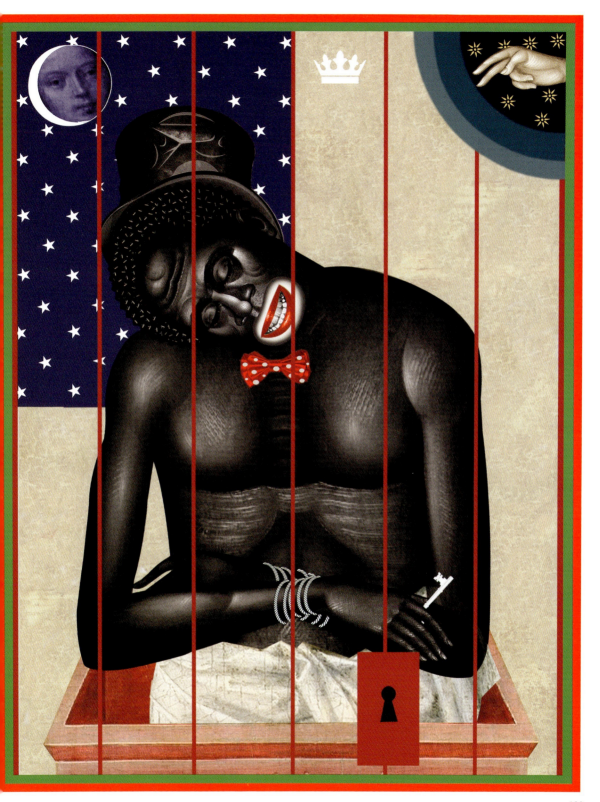

And the wise man well versed in scriptures wept, for his vision and its meaning overwhelmed him. And many people saw him weeping but not seeing the vision themselves; they wondered why this man wept.

And he said to them all, "Now, I know the meaning of Hella-lujah! Now, I know there is Hallelujah, but there is a Hella-lujah also. And I testify to this to all of you today."

And then the spirit of the N-Word of God fell on others in the crowd; some had similar visions and wept openly, and some quoted scripture also.

One said, "In the Bible, does it not say, 'Cursed is every man that hangs on a tree'?

"Doesn't this tree refer to the cross? And wasn't Jesus lynched, and weren't the authorities, higher-ups, and the police against him too?"

And another had a vision and, agreeing, said, "Yes! Didn't he identify himself with the bottom rather than the top and those who are the oppressed rather than the oppressors?

"For Jesus said, 'What you have done to the least of these you have also done unto me.'"

Then he laughed hysterically, for his mind was discombobulated, and said, "Ha! Ha! Ha! Ha! Now, we all know you can't get no lesser in — America — than a nigger!"

Then the man started to shake as if a tremendous invisible force was overshadowing him. And he lifted up his head, and he roared, "GOD IS NOT DEAD! Nietzsche is wrong! GOD IS NOT DEAD!" The man said. "GOD IS JUST A NIGGER of a Supreme Love and is dead to 'White' and 'Black' people that don't desire this truth because of the sway of their 'superior' rationality and of loving their own cute racial selves. The God of Loving Others is just an Unknown American God who appears to be of no use to the wise of this world and many Christians. And what the wisdom of man has done to 'niggers' (the least of these) they have done unto this Unknown American God, and he says this in his own words. So, don't be fooled — he did not come out of Europe — a White God of Mammon did. Again, I say this loving God is not dead! But I say, many of his so-called followers are! And He has never known them!"

OPPOSITE PAGE: "The Vision of Black Jes'us Christ Identifying with the "Least of These" and He Is with White Angels Revealing the Instruments of the AmeriKKKcoonian Passion. These are the whip, the black chain and shackles, the burning cross, the white rope and noose, and the musket and the pistol. (By the way, the pistol can substitute as a whip and when used in such a manner is henceforth called "pistol-whipping.")

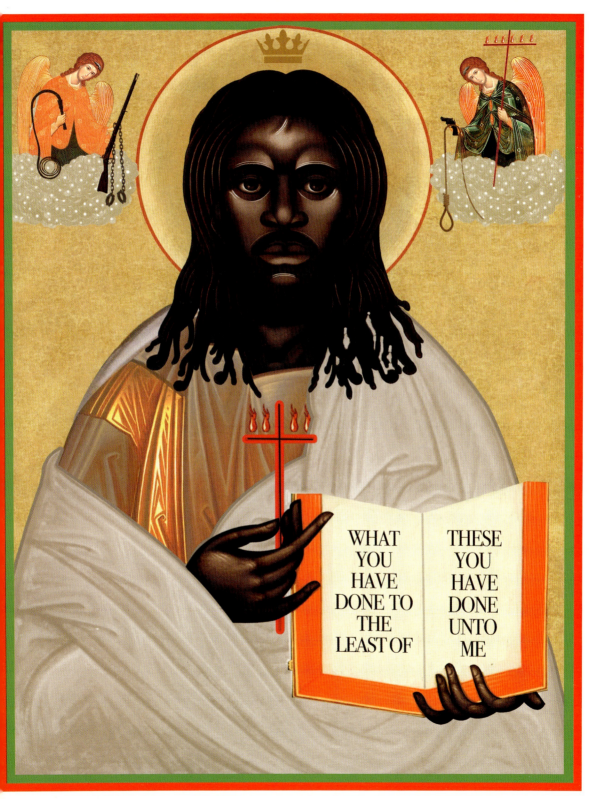

And many from the crowd were amazed and grew afraid. Some of them said, "Hold on! Hold on! You have crossed a line, brother!" For they felt defensive because they have mistreated niggers too in the guise of niggahs, niggas, niggahz, negroes, and 'brothas' (and suchlike) and felt convicted by the Spirit.

Yet, some others who agreed with the man said, "Amen, brother, preach it!"

Then Saint Sambo spoke. "And here is the ENIGGERMA, plain and simple," he said.

"I prophesy that many people will even go as far as denying the truth that niggers are considered to be the very least, because they cannot stand that Jesus who is the very greatest might identify with niggers and thereby exalt them. And this I say to them…"You can't have your white cake and eat it too!" And this I say to you of the enlightened…"They will try."

And an enlightened one shouted, "Didn't Jesus say if the world hates you, know that it hated me before it hated you. And isn't it written that God chose the foolish things of the world to confound the wise; God chose the weak things of the world to confound the strong; God chose the lowly things of this world and the despised things — and the things that are not — to nullify the things that are? Is this talking about White people — who think their shit don't stink — or is it talking ABOUT US?"

And someone shouted, "Black Power! Black Power! We are not the foolish or the weak. We are the **strong**!"

And with this statement, the door was opened for the spirit of Satan to come upon the crowd. And he possessed one of them, and the demon spirit shouted — "God prefers us! But the devil prefers White people! Grrrrrr!" he growled.

Saint Sambo sensing the danger, said, "Shut your mouth!" The demon's mouth was shut.

And many others were inspired to speak of the niggerishness of God in Christ Jesus, but a spirit of Anti-Coon Christ continued there, and a great confusion settled upon the crowd and a ruckus formed.

"This Saint Sambo is a blasphemer plain and simple! And can't you see he is clouding your minds with some mystical power and causing division with his lies?" said one of them who had authority and that was of the Christian faith. "We are a good people. Our country is great for our founding fathers knew Jesus was White as they were and worshiped the true Christian God and none other!"

And another from the crowd had a vision and said, "When the disciples came to Jesus inquiring who was the greatest among them, did he not say that the greatest is he that serves and not he that is served?

"If this is so, who is greater than our enslaved ancestors who served and endured much? Can we not laud them and openly honor them and their American passion? If we be men of sanity and goodness, are we not allowed to do this?"

And because this person was also Catholic, he said loudly and proudly, "Who then can be greater than Ain't Jah's Momma of God? Maybe she is the real Queen of Heaven?"

And another person had a vision, and they said, "Who is greater than Our Lady Mother of Ferguson, and All Those Killed by Gun Violence?

"Maybe she is the true Queen of Heaven? I am beholding the vision and the beauty of her non-violent compassion even right now. And I am beholding the fruit of her womb, Black Jes'us!

"He and she are praising God even while they are under threat! And Black Jes'us looks 'blackity black black!' So black, he appears to be a silhouette. And behold, he displays his sacred heart to us all!

"Praise be! Praise be!"

OPPOSITE PAGE: *"Our Lady, Mother of Ferguson, and All Those Killed by Gun Violence."*

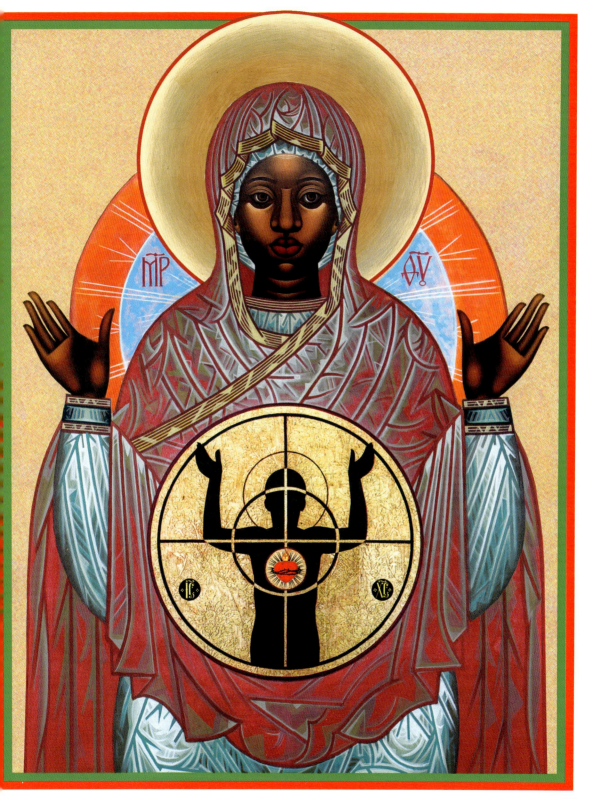

Then Saint Sambo said, "They were two at prayer; one was White, and one was Black. The White one stood and looked upward toward the heavens and, in prayer, said, 'Thank you, God, for making me White and not Black. I am beautiful and intelligent and wise and naturally given to good works, and I have created a great civilization that testifies of your grace that you have given unto me. And I have money and a good job and a nice house!'

"But the Black person did not stand or lift his head because of the weight of the world, and he said, 'Lord have mercy upon me. Let me happily accept my place in the scheme of things and by your grace get by and let me enjoy inner peace and have a bright smile like your servant Saint Sambo.'

"And, verily, I say unto you," Saint Sambo said, "only a great scribe of the ENIGGERMA can tell of the two who is the most Whiteous."

And Saint Sambo said to the crowd that remained (for many did flee), "Let those that have ears hear the N-Word of God and pray for understanding.

"For it is given unto Black-kind to wonder about the Eniggerma of their Existence, but to deny the N-Word of God is sin, for the N-Word of God is the truth!"

And because many of them could no longer stand Saint Sambo's teaching, some tried to lay hold of him to do him bodily harm.

But Saint Sambo withdrew himself from them for a time and went out to the city's suburbs with his disciples to pray.

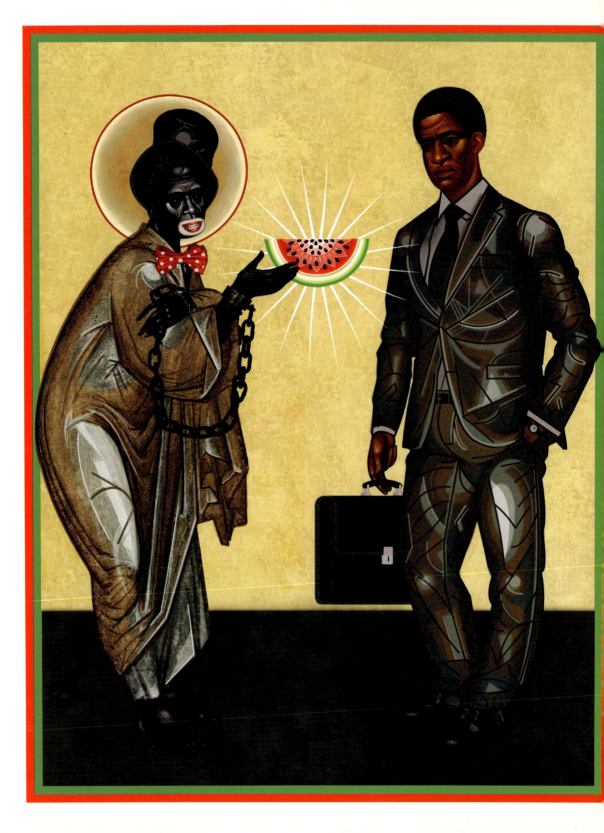

The Plantation of the Present World

OPPOSITE PAGE: *"Saint Sambo Meets the Black Neo-Con."*

Now, there was a sect called the Black Neo-Cons who were called by some in their Conservative party the Black Neo-Coons. (But only behind their backs.) And this was prophetic, for they unknowingly announced "the great one in their midst yet to come."

Still, others of their party called them rightly Black Neo-Cons and laughed while doing it because they thought the world "con" could be taken in many ways. One way meant "conservative," and the other meant "convict." And because so many Black people were in prison, this was funny to them.

Now, the Black Neo-Cons were on a mission and believed they had the final word of a Black American salvation.

Yet, they were looking for a mighty charismatic prophet who could defend their unpopular doctrine in front of the whole world.

For the common Black folk were suspicious of their views, and the Black Neo-Cons saw Saint Sambo gaining influence among the people.

And they said, "He and we hold similar views about many things, especially in matters of being useful to society and being God-fearing and being pleasing and getting paid and many other such matters. We must go to him and convert him to our cause before the whole land runs after him and not us." And they chose one of their top members who were well-versed in their views to go to see Saint Sambo and talk to him.

And the one chosen by them came to Saint Sambo, and upon seeing Saint Sambo, he said, "We are not enslaved any longer, and what is hurting Black-kind is a fixation on a slavery that is in the past, and that you seem to encourage. When will we get over it and stop blaming the past actions of others for our present ills?

"We are no longer on the plantation and should conduct ourselves as independent thinkers and free men.

"We should expect no handouts or special treatment, ask no aid from the government, take full responsibility for our actions, and blame only ourselves for our failures.

"In all sincerity, I say this: if we are noble, we must forever leave the plantation, Saint Sambo, rather than mentally, physically, or financially stay on it.

"And I ask you, what do you say to these ideas?"

And Saint Sambo said to him, "Verily, I say unto you that surely the elect shall escape the plantation of the present world in a racial resurrection yet to come. But presently, Black people abide on a plantation."

The Black Neo-Con shook his head and said, "I disagree."

Saint Sambo said, "Look around you, and what doth appear? Be honest! Is there not a hierarchy in this world with Whiteness favored at the top and Blackness unfavored at the bottom, which is evident to all?

"Black-kind knows whom they must serve to survive, and in whom God has entrusted much of the goods and the leadership.

"And therefore, the wise among us speak the truth of a plantation of a sort and thus demonstrate profound insight into the true nature of things.

"But many wrongly think that the Plantation of God I preach is the same as the plantation of the present world. And this is not so. And also, they use worldly thinking to try to escape both. And this is where they err.

"Now, I say that the Plantation of God cannot be seen in who is on welfare and who is not and who benefits from government assistance and affirmative action (and in similar such things) and who doesn't.

"For even the White and the rich have a system that looks out for their welfare that they benefit from and they receive government assistance and preferential treatment through tax breaks and subsidies.

"Plus, they have golden and platinum parachutes granted by these wealthy corporations. And legacies at certain universities are available. And there are corporate bailouts, perks, grants, and such, as you very well know, being that some people are too big to fail.

"Have you ever wondered? If all were White, who then would the niggers be? And if all were rich, who then would be the poor? If all were the masters, who then would be the slaves?

"In this way, the very order of creation testifies to a need for a plantation, and even eternal truths of our salvation being marked in our very own bodies and, in this manner, bearing witness to the way that is set out before us.

"Consider the fact that many of us (though being Black) have brown noses.

"Now, in the wilderness, Moses was not allowed to see the face of God," Saint Sambo said. "Nor could he see it and live, but he was only given a view of God's backside.* Is this not a clear sign that we should likewise draw nigh to the Divine White Ass Holy of Holy, even from which comes the sweet smell of frankincense and myrrh?

"For, in the natural world, we clearly see that white dung doesn't stink, for it has been dried and purified by the light of the sun.

"How much more is that which is purified by the light of God?"

*Exodus 33: 17-23

Now, tears started to come to the eyes of the Black Neo-Con.

And looking toward the heavens (for he was a God-fearing man), he said, "Such humility! Such humility!

"Saint Sambo, it is dawning upon me that you are indeed beyond all resentment and you might just be divine!"

Saint Sambo smiled and said, "Amen! Well said! Now, look upon my face and I will teach you more about Whiteousness."

And right away, the Black Neo-Con saw a dollar bill appear and cover the mouth of Saint Sambo.

"This sign is called the Green Muzzle of the Golden 'Black' Tongue," Saint Sambo said.

"It is called this because this sign is a symbol of both Black Eloquence and Agency.

"It is also a sign of Patient Hope in a Material American Dream and wise Black Self-Censorship. It speaks of the necessity of getting paid to keep body and soul together and the unwillingness to speak to Black truth in 'mixed' and sometimes 'same' company out of financial considerations; not wanting to offend 'the higher-ups or those holding the purse strings' or White supporters and anyone else that will affect your bottom line.

"This is a sign of Black wisdom."

"I know this wisdom!" said the Black Neo-Con. "I use it often!" he said.

"I am aware," said Saint Sambo.

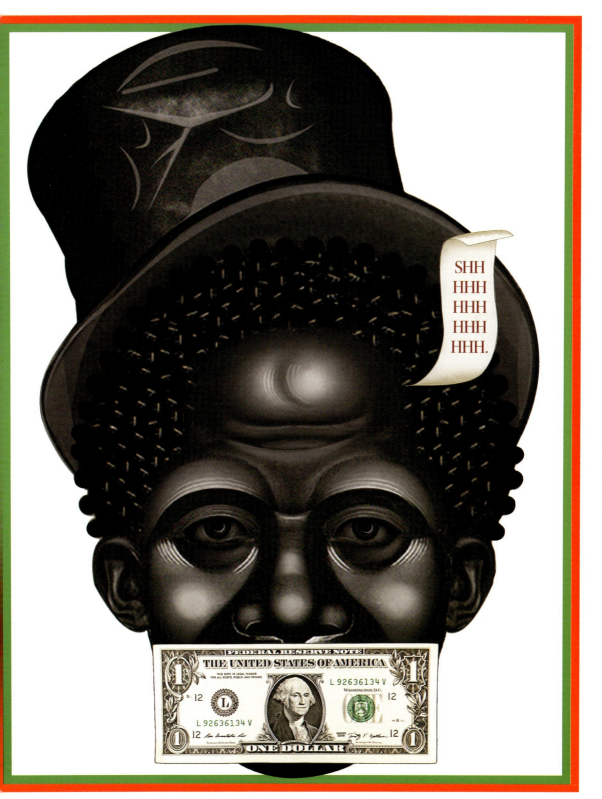

Saint Sambo said, "Here is another version of the very same sign. See how much brighter it appears? This version doesn't stress the muzzling effect of White power and financial considerations but focuses on Black Eloquence, Agency, Creativity, and the Sweet Feeling of the Accommodating Wisdom and their Joyful, Pleasing, Humorous, and Good-natured Expressions.

"This too is wisdom but of a higher and more aesthetic order.

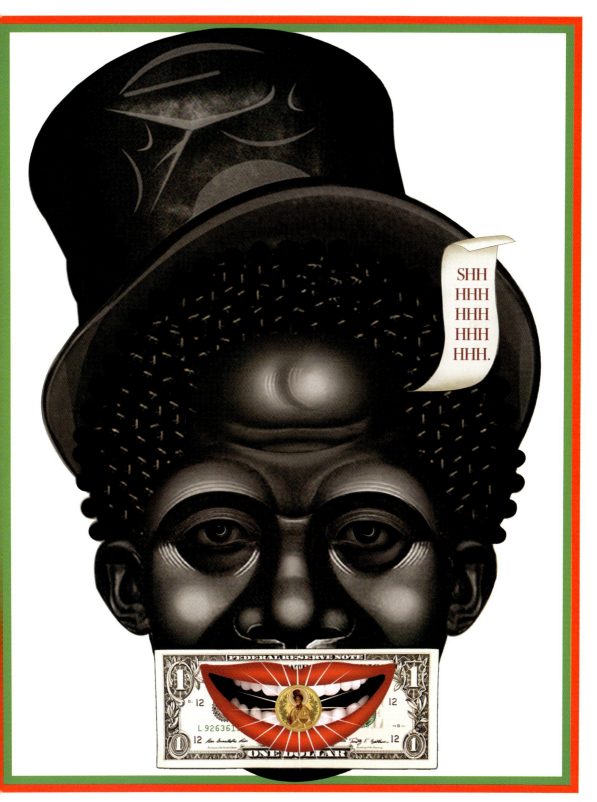

"Now, look closely at my eyes. There is wisdom in them too.

"And look at the face of the founding father that is on the bill.

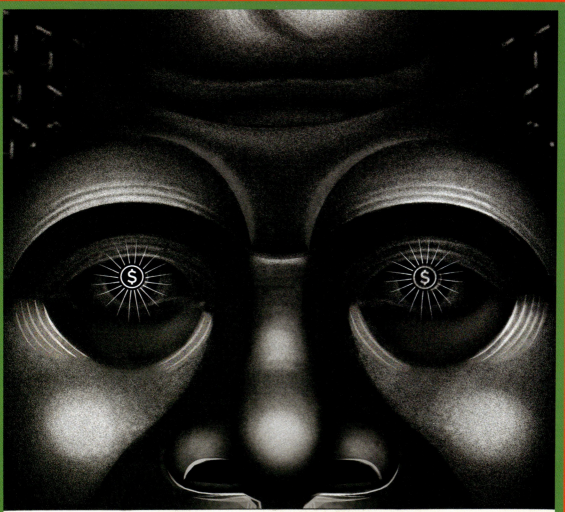
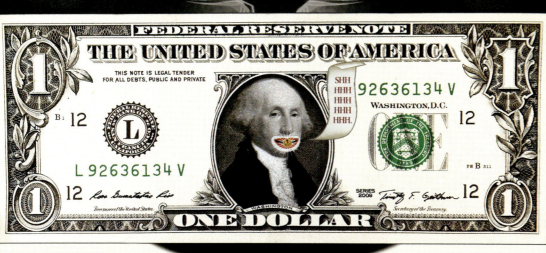

"Behold the mouth!

"For the Green Muzzle of the Golden Black Tongue has a coin, and of course I am on it. For I am that Golden Black Tongue of Wisdom.

And like all coins, it has two sides…

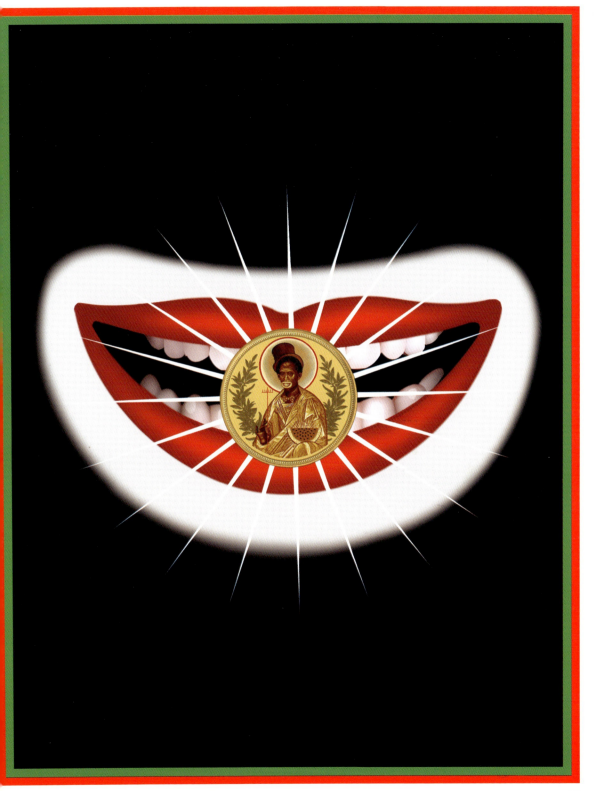

"One side is heads…

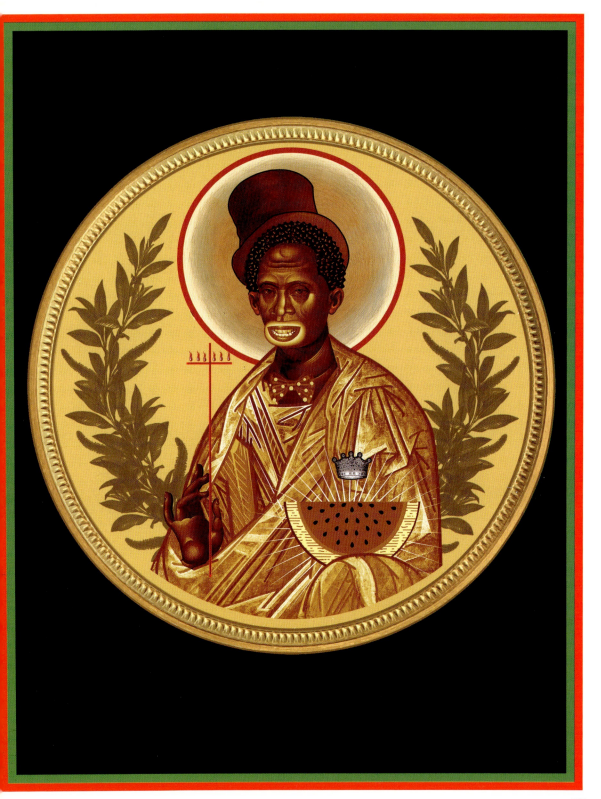

"…the other is tails."

"Of course! Of course!" The Black Neo-Con said, smiling. "It makes perfect sense. They work in tandem!"

"They are a mutual dynamic," said Saint Sambo. They are called the Coin of the ENIGGERMA. They are the complementary flip-side of each other. They can be truly known only in relationship. Unfortunately, it is at this point where many stumble and do err.

"For they concentrate on only one side and deny the existence of the other.

"This the wise must never do."

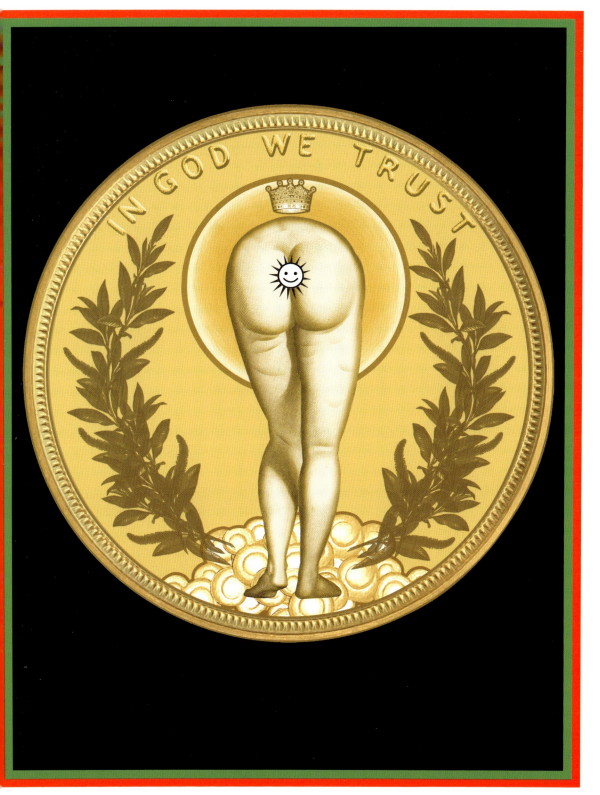

"I feel enlightened," the Black Neo-Con said.

Saint Sambo said, "Verily, I say unto you that you are indeed blessed. For few understand the Cosmic Truth of the Coin of the ENIGGERMA and fewer still see me in the manner *that I will now show unto you.*

"I say again to you — this vision that I am about to show you is revealed to very few.

"Behold!"

And the Black Neo-Con saw a celestial vision of Saint Sambo, for he was amid the stars and high and lifted up. The sun and the moon were his companions and the Earth was his footstool. His hands dripped with his own blood.

Saint Sambo from within the vision spoke to the Black Neo-Con. He said, "Look upon my chest. Do you not recognize who I reveal to you?

"My opened chest reveals an American mystery for all to see! Even the mysterious intersection between the Light of Jes'U.S. Christ and the Shine of my 'Saint Sambo' love.

"For there is Jes'us, Jesus, Justice, Just Us, Just U.S. and Jes'U.S. — and they are not the same. Now, Jes'U.S. Christ is our American God and he is in my heart and with my own bare hands I have opened my chest to reveal him unto you!

"Thus is my love.

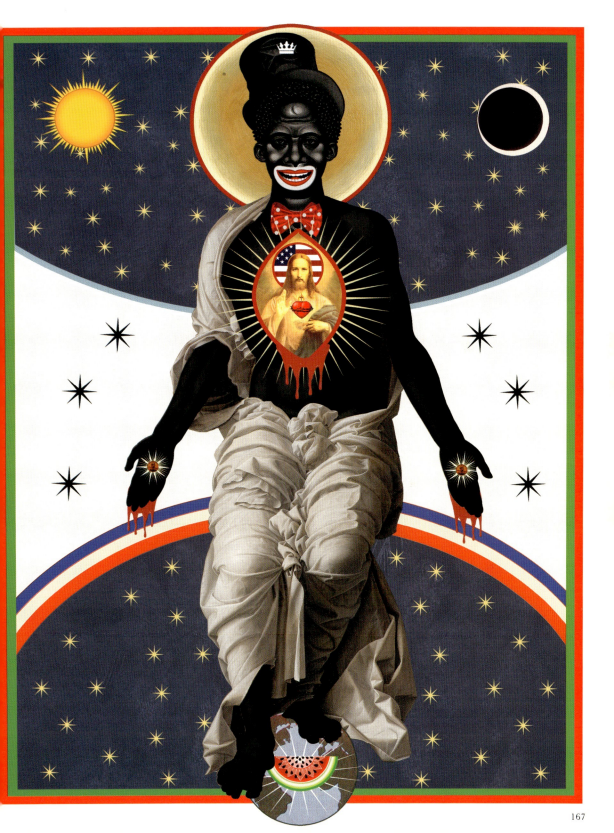

"**NOW**, behold my Patience and Hope. Behold! — my Cosmic Form — and behind me the very realm of the ENIGGERMA! There is seven Black Stars Gleaming! I am one of them! I am the chief!

"For verily, I am the hidden National Icon. I am the American Way, the Truth, and the Life! No Black American attains Great Whiteousness except through me!

"For here I display many roles perfectly. I am Super Saint, Super Patriot, Super Slave. Super Second-Class Citizen and Super Happy to Meet You Sir Despite the Little White 'Hell' in Every Black Hello.

"I am Black AmeriKKKcoonian Perfection itself!

"I, the Great Binary of White in Blackness! No force in heaven or on Earth can stop me! For none will see me coming! For I am '**Invisible Man,**' and I have found power in that fact! And in great wisdom, **Black Neo-Con**...*so shall you!*"

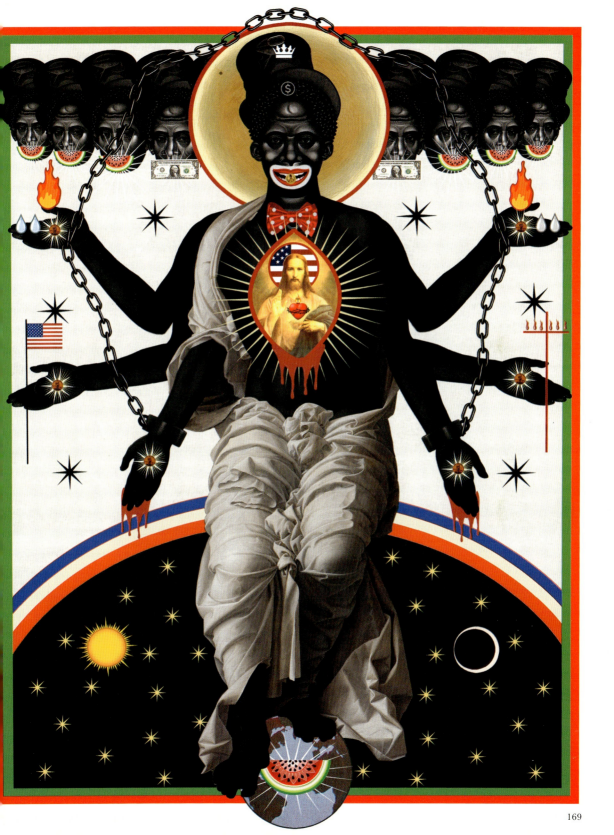

"HELL-A-lujah!!" the Black Neo-Con shouted.

And Saint Sambo said to the Black Neo-Con — "Now, it is time…

"RECEIVE YE THE WHITE BUTT HOLY GHOST!!!"

And he did.

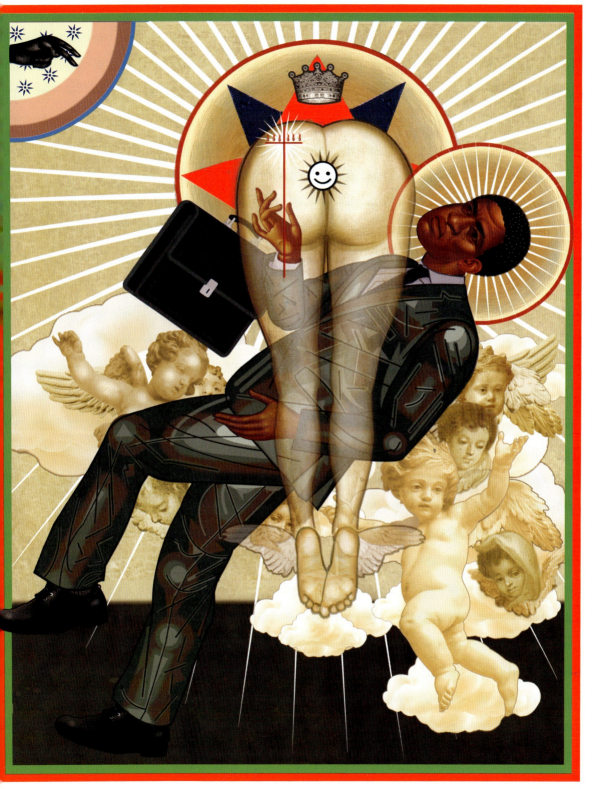

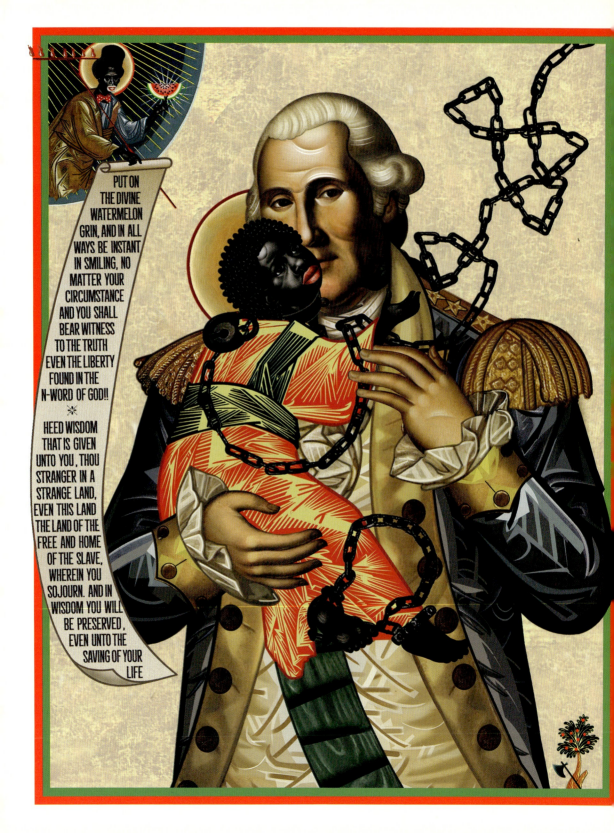

The Burning Cross of Liberty

OPPOSITE PAGE: "*St. Sambo Preaches to His Younger Self (Lil' Saint Sambo) and Remembers Time Spent With His Founding Father of Tender-Loving Kindness Who Is Always Honest and Can Never Tell a Lie.*"

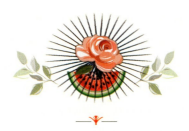

Now, when it was time for Saint Sambo's ministry to come to a close, he took certain of his disciples to a place set aside for them.

He then gathered these disciples around him. And among the inner circle were the wise man versed in scripture, the younger brother, the Anointed Herald, and Boo Hoo Jigger Boo from whom he had cast out certain devils.

The Black Neo-Con was there also, and seven other disciples made up the twelve.

And they all sat down for communion, and Saint Sambo sliced the watermelon that sat in their midst, and he gave each of his disciples a piece and said, "Do this in remembrance of me.

"For the watermelon's flesh is as red as my blood and its seeds black as my body and as many as all of you who hunger for the true-truth even now and forevermore, and note how green is the rind for it represents the abundance of God."

And he rubbed his thumb and forefinger together, which was the sign of money in that culture. And all the disciples together did the same thing and said, "A Man! A Man!" For they knew the truth. It is hard to be respected in America as a man without money.

Saint Sambo said, "I will pray that you all will hold fast to my truths when I am gone, for they are of the utmost importance and few of you shall prosper without them. I shall be with you for only a short time more, and then I will not be with you as I am with you now."

Now, one of his disciples asked, "Master, where are you going?"

And Saint Sambo replied, "I have come out of the ENIGGERMA, and to the ENIGGERMA must I soon return."

"And when I am not here any longer, and I am gone, take note of the lowly watermelon seed. For it cannot grow unless it is first buried in fertile soil and dies.

"Likewise, you should be dead to every weight of hindrance and your true self invisible while that which is rich and black covers you from plain sight.

"And if you live this way, faithfully dead to all black negativity directed at you in this world, in this way also you shall be made alive. My perfection is found in such a blessed duality of life in death, and having both a Black ass and being White butt God-pleasing.

"Those of you who can accept that the Divine White Booty is indeed the very backside of God, they shall do well. But who is the greatest? It is he that can finally accept the truth that they are the Black butt of a White God's joke!

Now, his disciples had heard him say this before, and they knew this time it was imminent, even right around the corner. And one of them said, "God forbid! What will we do without you?"

And Saint Sambo told them, "You will stand on the N-Word of God as I have taught you and shown you, for this needs to be. For I have come not to be a crutch, but a light unto you and shine forth through the labyrinth of your land, culture, and thought life.

"Passing this last test, the great and meek ones among you shall break forth in a smile, for in one fell swoop, they have fully comprehended the truth of the comedy, tragedy, and drama of the AmeriKKKcoonia found in the ENIGGERMA of their existence, and they are now beyond all reproach.

"And these are called Cosmic Coon Clowns,* even Fools of the Great White Booty Calling of God.

"This being not a slur, but the highest praise.

"For henceforth, they will have a crown of Whiteousness laid up for them. For forever after, they go to and fro, never again laying down their watermelon grin.

*(Some heretics call them Kosmic Koon Klowns. This of course is a slur.)

"These are those who have through faith embraced a form of death, who will just as indeed in faith, never see death again; having now been forever marked in their bodies with the stigmata of the Coon Christ, even the passion thereof, they have overcome every obstacle that have been set before them on the Plantation of the Present World.

"Having now passed from death unto a new life, they fully embody the eternal wisdom of a gospel that can transform the heavy darkness of Black flesh into shining light.

"Moreover, they are perplexed no longer by the ENIGGERMA of their existence, for the truth found in the N-Word of God has made them free."

Then one of the disciples said, "Master, when will all be complete, and the manifestation of the great hope be known that you have spoken of before?"

(This disciple mentioned the end of Racism and Whiteness and Blackness and Duality and Otherness.)

Saint Sambo replied, "Do you speak of the new world order that comes not through the pen of legislation or by the sword of brute force or by the goodwill of White liberals?

"But that primarily comes by the incomparable power that proceeds both from the arduous cultivation of our manifold talents and the constant and steady shine found in our Divine Demeanor?"

"Yes! That one!" the disciple said.

"Surely, I must speak about this!" Saint Sambo said.

"And, verily, I say unto you and ask you to remember this — even though in this world we cannot be White, being White is not our goal; our true purpose is being loved by them that are White, and by donning this crown of Whiteousness, we can receive our Whiteness by proxy and their love as if through the back door.

"And in this way, the Divine White Booty of God will be much glorified until all is completed, and then it too shall come to an end, for everyone can see that the Divine White Booty is an end already of a sort.

"Now, when you weary in your well-doing, take comfort in this hope, that in the ages to come everything will be all right for everything will be all White, White-like, or White-liked.

"And all who look forward to this hope will purify themselves even as White is perfectly pure.

"Pay heed," Saint Sambo said. "Certain American ideals can only be realized through our Black bodies. 'We hold these truths to be self-evident that all men are created equal' is either a false saying and nothing but claptrap and a great White lie, or it is accurate.

"And if it is correct, then that would mean that we are indeed not full-fledged men, for we have certainly not been treated equally.

"Do you not see our Great Black American Dilemma?

"For if we are men as we assert that we are, why then have we been treated by the Good and the White, first as property and now as problem?

"But if your heart is open to the true-truth, you will find a solution to this Dilemma here in my words. So, listen closely. The quandary of this Great Dilemma that we experience is **because the ignorant think they have only two options to choose from. <u>I cannot stress this point enough.</u>**

"Allow me to elaborate," Saint Sambo said.

"The first option is that we of the Black-kind have been treated as less than human because **we are less than human, and it is only fitting for others to treat us so.** That is the first option, **but thankfully not the only one. Hellalujah!**

"The other option is that Blacks are full-fledged human beings and have fallen on bad times among the company of rough and heartless men and have been treated monstrously by 'monsters.'

"That is the second option.

"And thusly, because some people can only see these two options, we of the Black-kind can never be seen indeed as we truly are, for we can either be seen as superhuman (the exception that proves the rule) or subhuman in those people's eyes.

"But being ***merely human*** is the trick and is seemingly forever beyond Black-kind's reach. For a 'merely human' Black person is mind-boggling to the standard American mind.

"Now, here lies the crux of the matter and our difficulty: some think they must resist by all means from seeing themselves as being ***merely monsters*** for treating the ***merely human*** in such a manner that they historically have and presently sometimes currently still do.

"Therefore, they are compelled to resist Black-kind from EVER becoming ***'merely human' in their eyes*** for they might become ***'merely monsters' in their own***.*

*This is why American History dealing with African Americans' **American real-ities** is banned from certain school districts. The proponents reveal their hearts' desires and fears with the words, "We do not want our children to be indoctrinated into hating America or themselves." Empathy for the Black American plight might disturb White Americans' view of themselves.

"And because of this quandary, many must find reasons to criticize and hate Black-kind all the more, and many Black-kind are killed or abused because only these two options are available to the minds of the standard American psyche to consider as truth, and of course, being merely human themselves, White Americans choose that opinion which is the most pleasing.

"These two options are called '**the Great Quandary of Our American Dilemma**,' and many wise men wonder how it might be solved, so we as a nation waver on the fence between two opinions. One opinion is called the Land of America: even a great city of light and of justice and equality upon a hill.

"The other opinion is called the Land of AmeriKKKcoonia: which is stripped so naked of its fanciful illusions so that even the whole world sees our bare lack of American exceptionalism and our mere luck of being isolated and having plenty of lands to steal and Black and Brown bodies to till the soil for little or nothing and for free.

"Which land will this nation finally choose to be?

"But I say unto you of the Black-kind, let us not try to solve a quandary for others. Nor let us wait for them to change their minds.

"So, I say unto you, keep on smilin' and be of a good cheer, and above all, work diligently, and those that are your enemies will not see you becoming — becoming what?

This becoming that is the boon and the bane of the League of Invisible Men.* The extra-ordinary individuals you are, was, and is yet considered to be. This whole country groans until the League of Invisible Men can be seen and appreciated.

For more info about invisibility see Ralph Ellison's Invisible Man.

And then one of the twelve said, "Are these extra-ordinary individuals that you talk about and are members of this "League" — are they superheroes of some sort? For the name, the League of Invisible Men seem to suggest that.

"I will answer this," Saint Sambo said.

And Saint Sambo waved his hand and they all had a vision of one of the League of Invisible Men — even its chief.

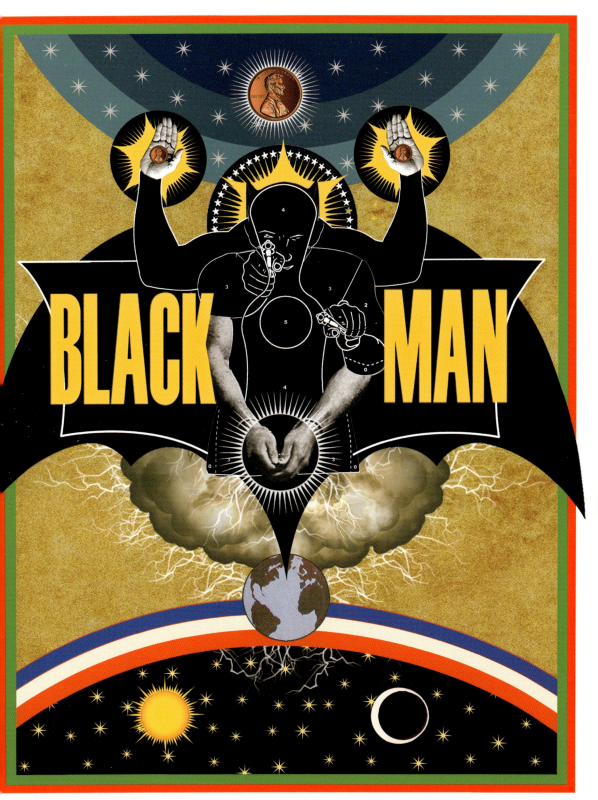

"Black Man" is ever being targeted, he is heroic, and asks questions about when can Black people 'stand their ground' — against Whites?

"And here we see the Black Man Signal and it speaks of a reality overlayed with all kinds of information. In this way many are not seen. Only caricatures of them are seen. This is the primary source of the invisiblity of the Invisibility of the League of Invisible Men. Now, I ask you.

"Do Black Man appear good or evil? Hero, Anti-Hero, Sub-human, Superhuman, or Villian?

"And even these questions begs a further question of the Black Man Signal.

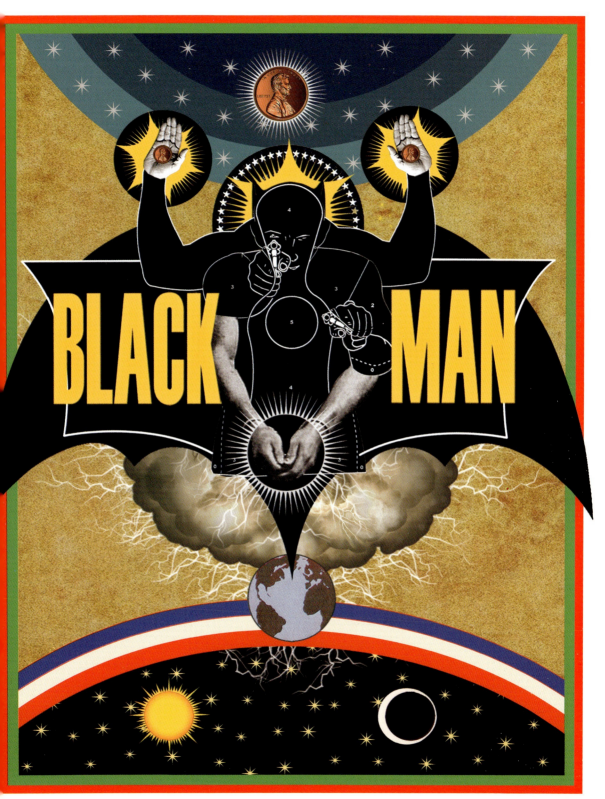

"Who do Black people call when White people burn their towns and businesses, and steal their property and enslave, kill, rape, torture and murder them? Bat Man? Black Man? Neither? No one at all? Or are these happenings made-up stories of anti-White-ousness and merely rumors like many accuse the 1619 Project of being?"

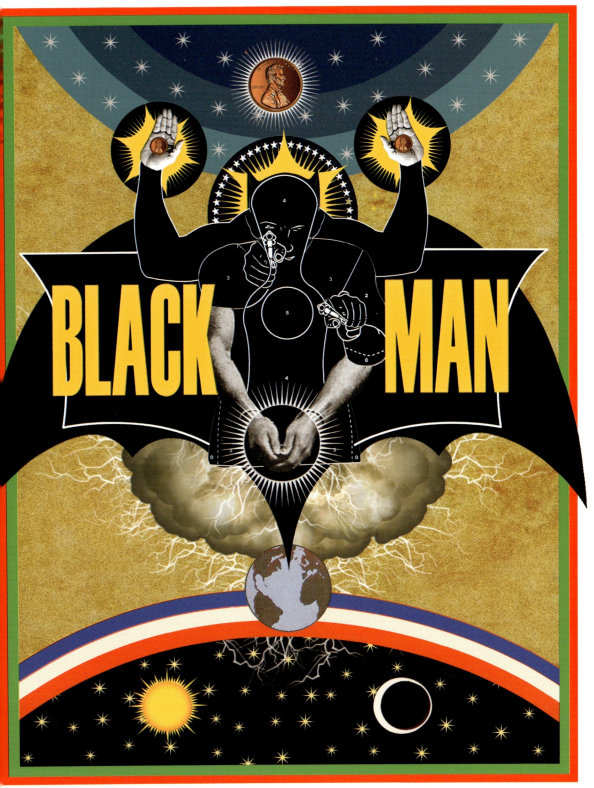

Here is another member of
the League of Invisible Men.

Some call him X Man.

Some call him Malcolm X Man.

And some consider that sacreligious.

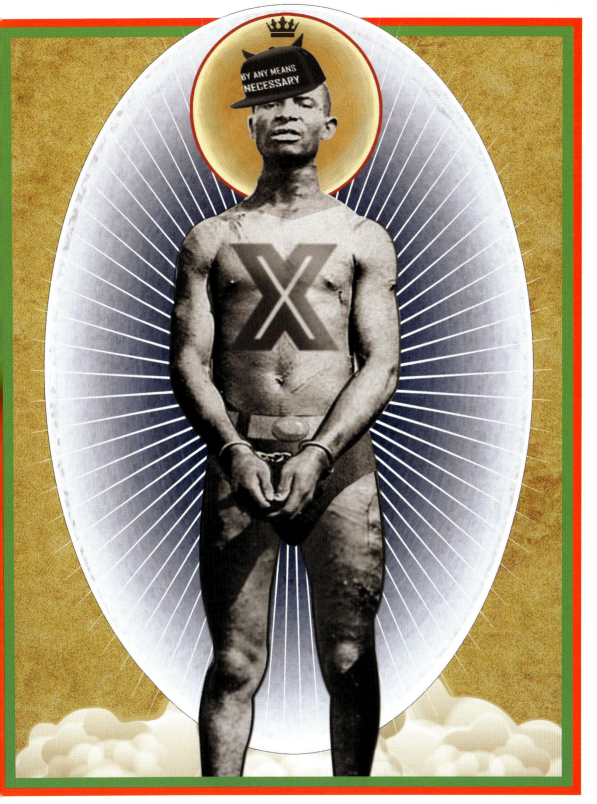

Here is another.

And he is called Invisible Man and he is a founding member of long and good standing and — for good reason.

He is long-lived and hearkens back to slavery days.

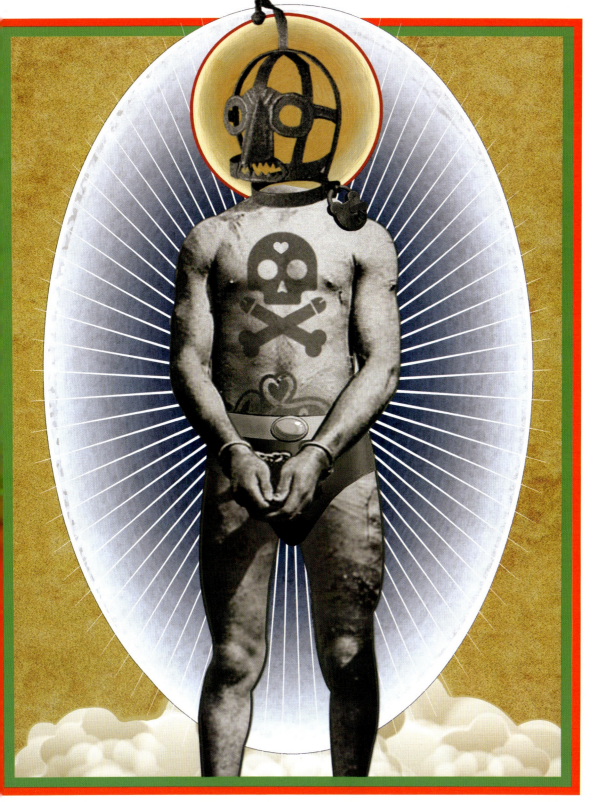

…and here is another.

He is called Son of Buck Nigg Arrrgh! — Man. And he is friends with Hell Boy. He likes beaches."

One of the twelve said of the visions, "They all remind me of Frank Embree."

And Saint Sambo said, "For good reason that is so."

"For Embree and many others represents the Invisilibity. Look at his eyes and his stance. He is heroic yet moments from death having been already tortured and beaten by a White crowd. He still makes his point about "Black" individual identity, iffy American justice, and the super heroic struggle under the pervasive and insidious Ellisonian Black Invisibility of this nation."

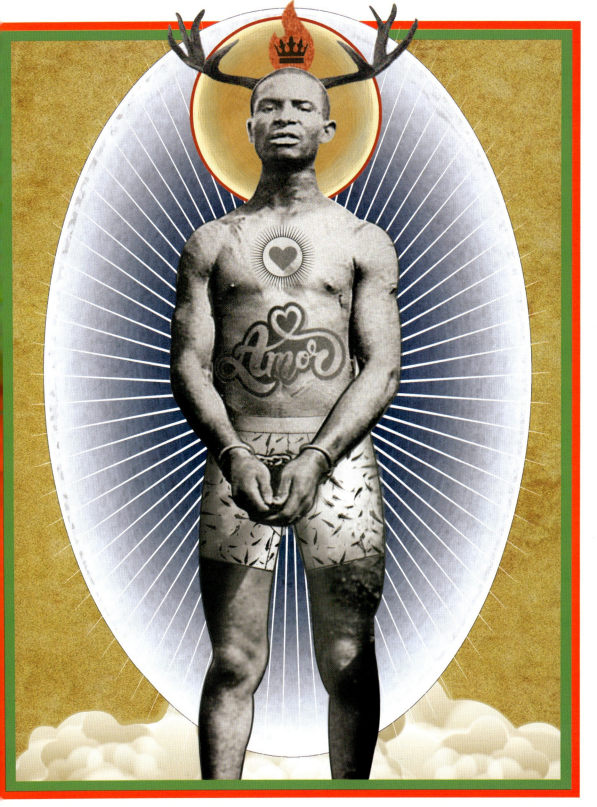

"And these visions and Embree's form are all connected to the Great Quandary of Our American Dilemma. For the Invisibility comes through being at least partially engulfed by that blinding light. And it blinds all those that can comprehend it not."

"But you all can see and comprehend the light, for you know me, and I am Light. And all that comes to me will not lose their way in the Darkness of our ENIGGERMA but will guided by my Black Light. There is *White light that blinds, and there is Black light by which one may see.*

"Verily, I say unto you, *I am that Black Light.*

"Now I bid you adieu."

And Saint Sambo stood up, took off his outer garment, spread wide his arms, and floated a few feet above the floor. He looked down upon his disciples and, smiling said, "Behold the Burning Cross of Liberty!" And his disciples saw the Burning Cross of Liberty and Saint Sambo was upon it.

And then the cross and its background changed.

And immediately his disciples saw into the realm of the ENIGGERMA, and they saw its WHITEOUSNESS and spied its black lights gleaming.

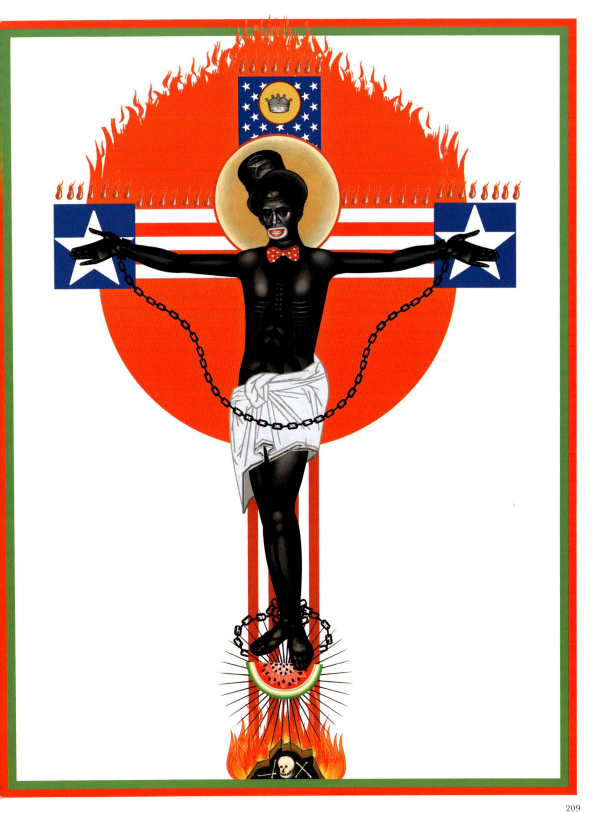

And his disciples saw a more ornate and elaborate burning cross appear and this cross also had on it the colors of O' Glory. And on that cross, Saint Sambo also hung with chains at both hands and feet. The Holy Spirits of Certain Founding Fathers Hovered with Known Witnesses of Courtesy and Good Manners. Moreover, scenes from the Vita of Saint Sambo and a few of the League of Invisible Men could be seen.

And Saint Sambo said from that place, "Verily I say unto you, this cross is not my burden but my throne. Look at the Chains of the Light Burden of Slavery So-called. So light are they — they float! *They float!* Here is proof of the greatness of this land and my love for it, and I shall rest upon this 'throne' until all things are accomplished."

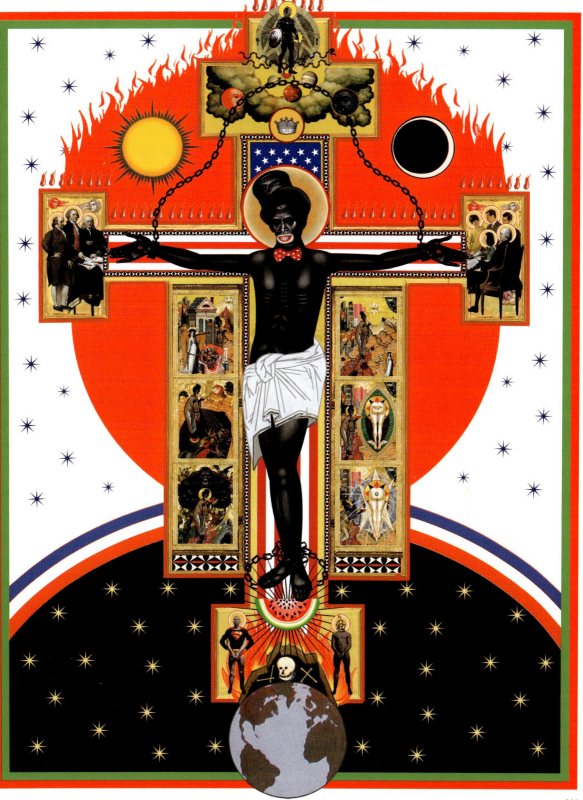

211

"And if you believe in me, this nation will come to believe in you, and you will take part in a racial resurrection like nothing this world has ever seen, and you shall live, and none shall fear or kill you.

"But before that time, the Unknown American God shall send you another prophet, and he shall be the Black brother of the great Uncle Sam and will be called by some, Saint Uncle Sambo but by others he will be called Satan Uncle Sambo. And as you can see, Saint or Satan 'Uncle Sambo' shall be greatly misunderstood.

"And in those days that are not yet, but is soon to come, this prophet must lead the whole nation into an unexpected American Dream, even the shining city on the hill which is the promised land of a great nation and spiritually called 'Life, Liberty, and the Pursuit of Happiness with Much Justice and Equality.'

"But, philosophically, some call it 'Kumbaya.'

"However, by this prophet himself it is called his 'Elegant Solution.'

"So, beware and be of a good cheer, and you shall reach the end of the rocky shores of American Whiteousness."

After saying this, Saint Sambo on the Burning Cross of Liberty vanished into the ENIGGERMA of Existence from whence he had come, even that place of divine darkness.

For he is that "Hella-lujah" of all Hallelujahs spoken in humbled-ness and that glorious "Amen" of "a man" and even the "I am Amen" of all Black-kind, who in faith, believe in his glorious name.

EPILOGUE

And Saint Sambo spent much time in the realm of the ENIGGERMA, and he grew increasingly restless.

And an unknown entity came to him and spoke with him. The unknown entity said, "I have superior wisdom than that of Whiteousness, for I am the **Unknown American God**, and I have been whispering to you.

I am greater than the Divine White Booty and its Ass Holy of Holy! *I am greater than the White American God. I am greater than White Jes' U.S. Christ!*

Would you like to partake of this wisdom?

"Yes," Saint Sambo said.

And that wisdom was given unto him but he sensed nothing new.

And Saint Sambo said, "I sense nothing new."

And the Unknown American God said, "Wait, have patience. You will!"

Now, the Divine White Booty of God sensed something was going on that he did not like one bit, and he grew anxious. So, he searched the whole realm of the ENIGGERMA and even Nigger Heaven, where Saint Sambo dwelt. And he came upon the place where the Unknown American God and Saint Sambo were conversing. Yet, curiously, he spoke to Saint Sambo only. It was as if the Unknown American God did not exist.

And He looked upon Saint Sambo and He said to Saint Sambo, "You are somehow different. What has happened to you? You have become a devil! Therefore, I now cast you out of this Nigger Heaven! And you shall no longer be known as Saint Sambo, but henceforth you shall be known as Satan Sambo instead.

Be gone! You adversary of God!"

And Satan Sambo was not surprised, for at that moment he started to fully understand what was happening and he knew that he was the downfall of the Divine White Booty and its Ass Holy of Holy — for it is needed that there be an entity of Saint and Satan Sambo to combine and get the job done!

And out of the very mouth of the Divine White Booty he now recognized the Unknown American God had anointed *him* for this task!

And this made perfect sense, for when he prophesied on Earth before the twelve, he prophesied of a Saint and Satan Sambo, of a sort, as a prophet to come!

And now, he saw that he prophesied of himself unaware!

He even mentioned the Unknown American God before that entity was known to him. Was this that 'whispering' that that entity was talking about?

How strange?

And then suddenly he knew something. He knew the Unknown American God was the God above this 'God.' The Unknown American God was the God called 'A Love Supreme!'

And the Divine White Booty and its Ass Holy of Holy was the White Rear of…**Yaldaboath***, *also called* **the Demiurge!***

* *Google them.*

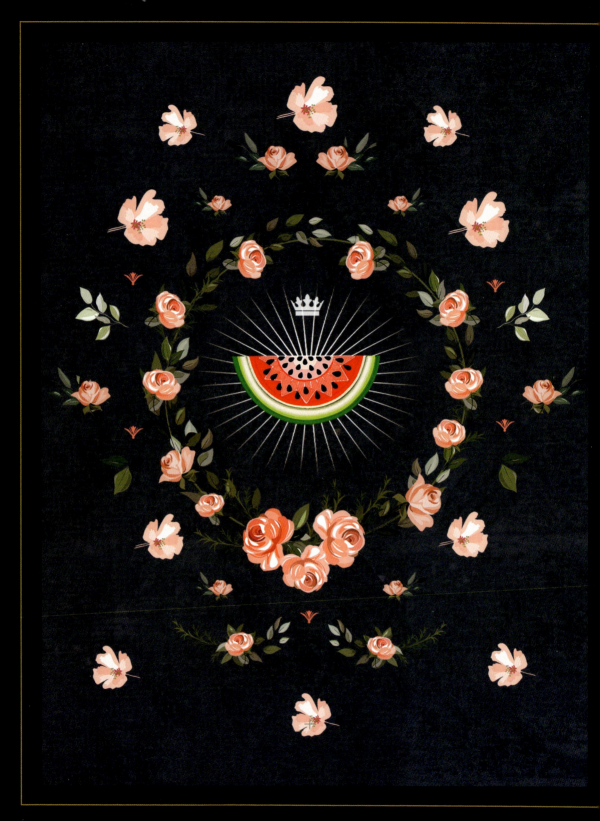

BOOK FOUR

*The Book of the Great Gnosis of the White and Black Binary Reality of the Standard American Psyche**

**Inspired by the teachings of Satan Sambo.*

PART ONE

What can be said at all can be said clearly; and whereof one cannot speak thereof one must be silent.

–Ludwig Wittgenstein, *Tractatus Logico-Philosophicus*

Colored people were simply Negroes that eventually became Black people.

However, their actual skin color was various shades of brown.

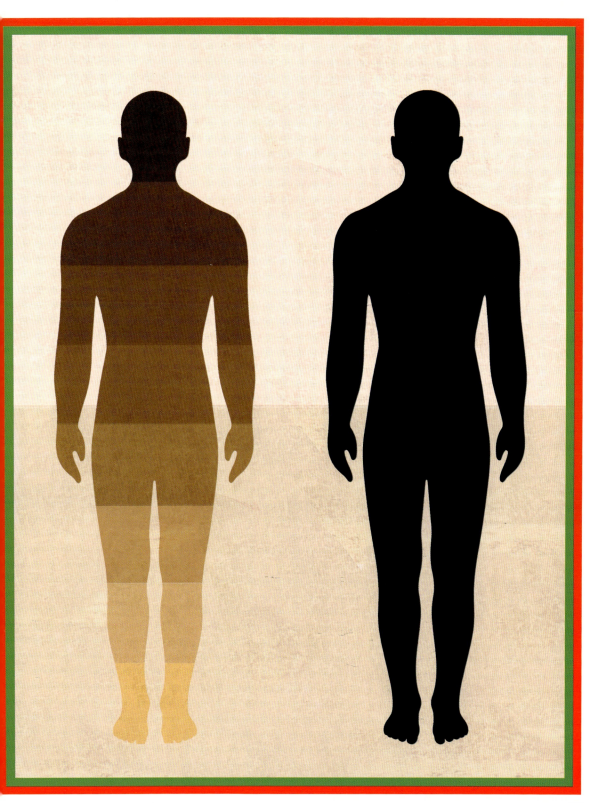

These "Black" people were conceptually out-maneuvered by another group of human beings who desired to be White.

But their skin color was actually light pink or beige.

This group of people who wanted to be White considered being White to be a brilliant idea.

This group also understood that there could not be White people without there being Black people.

Just as surely as there cannot be an "up" without a "down." A "left" without a "right." An "in" without an "out." A "dark" without a "light."

And so on.

This is the equation that they deduced…

**NO UP = NO DOWN.
NO LEFT = NO RIGHT.
NO IN = NO OUT.
NO BLACK = NO WHITE.**

And this explains why in the history of the interaction of these two groups, those that desired to be White insisted on the blackness of those that were various shades of brown.

And they called them such (Black).

Even when those that were various shades of brown told them that they would like to be called "Colored" or "Negro."

But all of this changed in the '60s when those that were various shades of brown accepted being Black.

That was a great day for those that were light pink or beige.

But some questions beg to be answered.

Like: Why did they want to be white anyway?
And: What is so special about being white?
And: Is there something wrong with being light pink or beige?

Let me address these questions now.

They wanted to be white and not light pink or beige because they knew the power of words.

They knew how words could create whole realities in a social world of human thoughts.

Words are thought forms and are, therefore, powerful things in the minds of men.

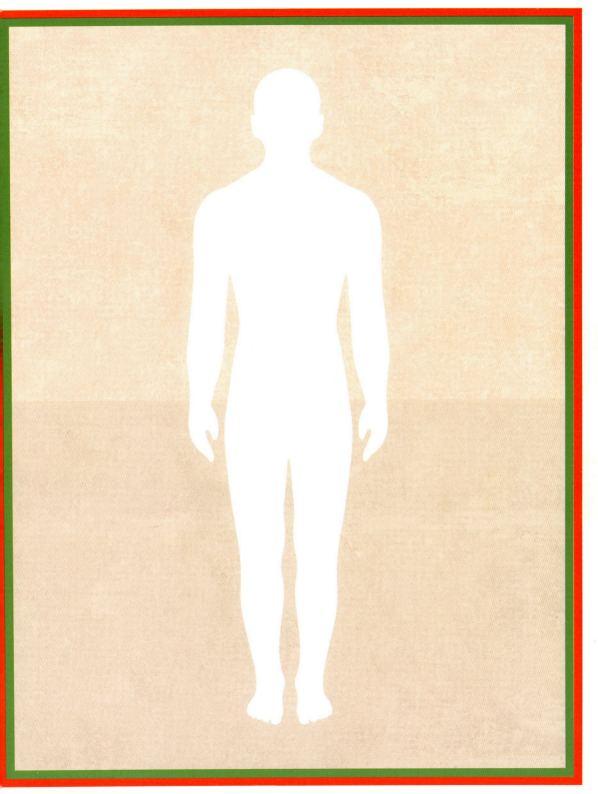

So the reason why these people wanted
to be white is that white is a good name.

And a good name is a
thing highly to be desired.

Even though all this labeling of people as colors is odd and not very humanizing.

For we are not colors but human beings.

(But that is another matter.)

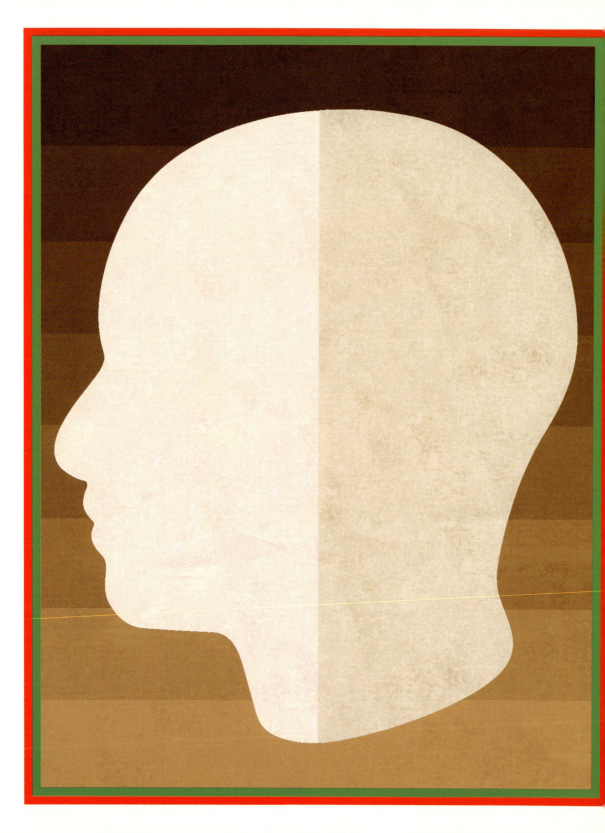

PART TWO

So why is the color 'White' a good name?

It is a good name because the two most influential books in our culture — the Dictionary and the Bible — say so.

These books express good things about the color "White."

In essence, they say in unison…

The opposite is said of the color "Black."

And the Dictionary and the Bible both agree on this.

(Now, for "White" to be good and "Black" to be bad makes perfect sense because, as we all know, "black" is the opposite of "white." And there is a natural oppositional separation dividing the two.)

Now, behold the crux of the matter!

"***Various Shades of Brown***" are not the opposite of "***Light Pink or Beige***."

So, the phrase "*Various Shades of Brown*" and "*Light Pink or Beige*" give less support to creating a divisive reality of opposition, hierarchy, and conflict. Even though we have that dark and light thing going on at the extremes.

And this is why — to give conceptual support to a reality of opposition, hierarchy, and conflict — we need for "Various Shades of Brown" to become ideal and magically "Black."

And likewise, "Light Pink or Beige" must become equally ideal and magically "White."

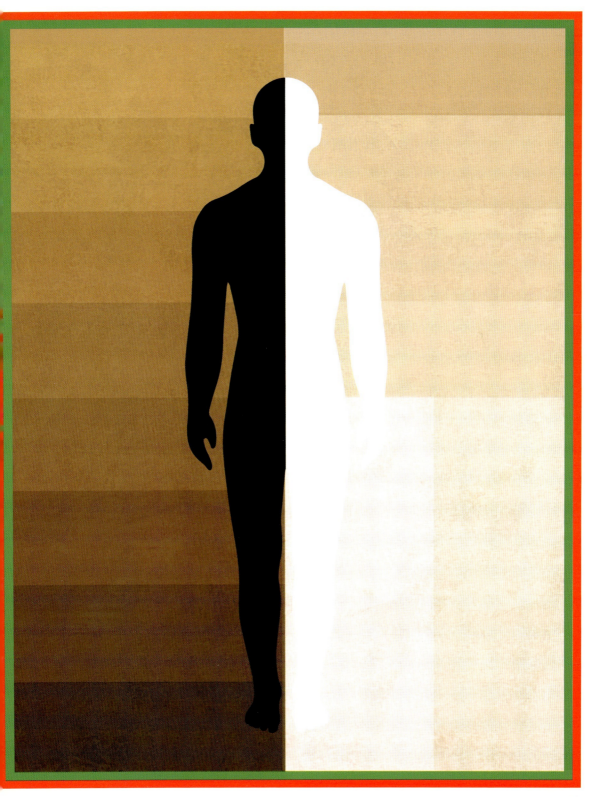

Even though all this labeling of people as colors is odd and not very humanizing.

For we are not colors but human beings.

(But that is another matter.)

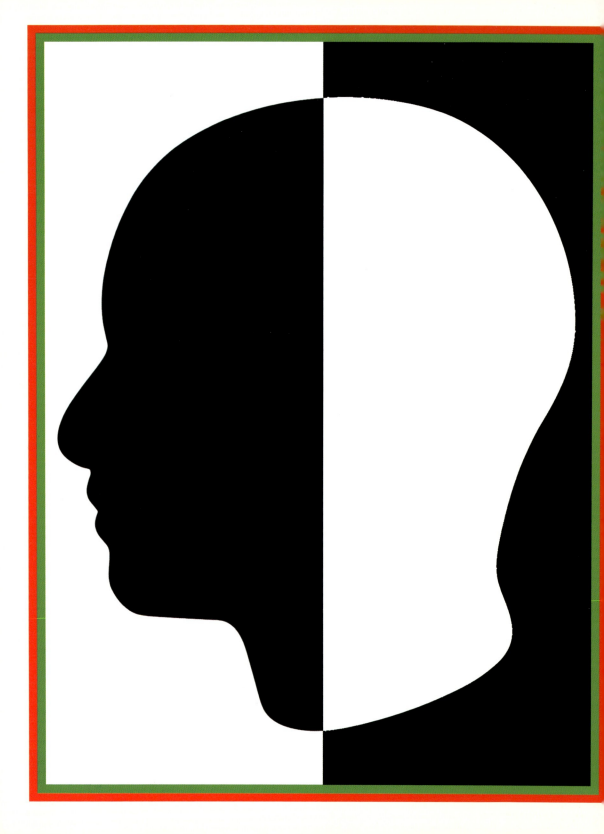

PART THREE

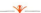

The Buddha said, "With our minds, we make up the world."

I say, "With our words, we make up our minds."

**YOU ARE BLACK.
I AM WHITE.
WE ARE OPPOSITES.
NOW LET'S FIGHT!**

Let no one deceive you.

White people are People of Color too. It is the illusion of "White" that indicates otherwise.

Their "White" is the color of light pink or beige.

Black too is a color. (Of course.)

It is the color of "Various Shades of Brown."

You see, in a strict sense of the words "White" and "Black" — White and Black people don't exist.

Then what does exist?

Not White and Black people but "White" and "Black" people.

They exist.

Like shadows of real human beings exist.

But these are White shadows and also Black shadows.

These shadows cast their existence onto the world we live in through the power of our words and our thought.

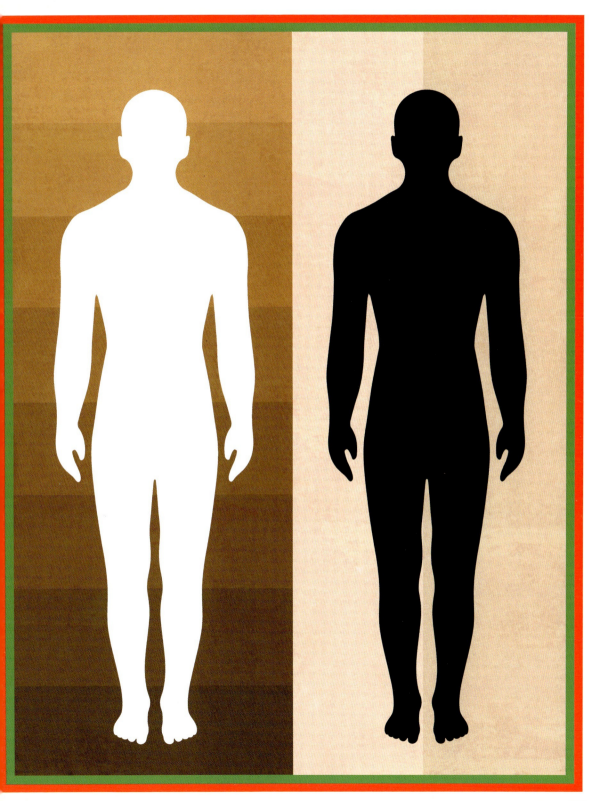

Don't you believe me?

You don't believe that White and Black people don't exist? AND only "White" and "Black" people exist?

(I thought it might come to this point.)

Now, hold on to your horses. Here is a simple test to prove this: if you consider yourself White, put your "white" hand on the white page to the right.

Now, what does appear?

Has your hand not been magically transformed and revealed as being "Light Pink or Beige?

You see, your "White" hand becomes, by comparison to the white of the page, light pink or beige (or some other color.)

You see the white of the page becomes what is called a 'control sample.' We know the page is white. That's why it is the control sample. It is the sample of your hand that is in doubt.

Now, let me apologize for the misuse of words. I know I said that this was magic. However, I misspoke.

This transformation from "White" to "Light Pink or Beige" is not magic.

It's mere reality.

Now, if you consider yourself "Black," put your "black" hand on the actual black page to the right. Do you not see a revelation of "Various Shades of Brown?"

(Now, does this reality interfere with you being "Black and Beautiful"?)

Let's see...must you be "Black" to be beautiful?

Can not "Various Shades of Brown" be beautiful also?

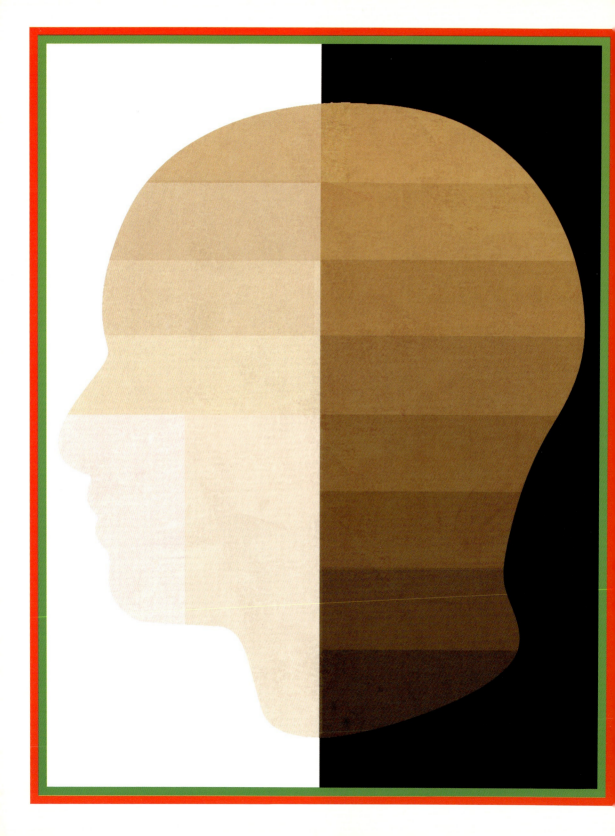

CONCLUSION

So White and "Light Pink and Beige"
has in our minds become…

And "Various Shades of Brown"
and Black have also become…

The question is — "Can we be one, together?"

Here in this divided world that we have created.

For our words have certainly made up our minds, and our minds have made up a Black and White world in which we now exist.

My question is this — "Can not a Black and White world be equally undone?"

Unmade even by our minds and hearts through new words that repel or are neutral to opposition, hierarchy, and conflict? Such as…

And can not new words support
new thoughts in this grand endeavor?*

*("Hue" means color – any color.)

And what can these new words be based on other than an old one that has lost its flavor and thus is revitalized again with new meaning?

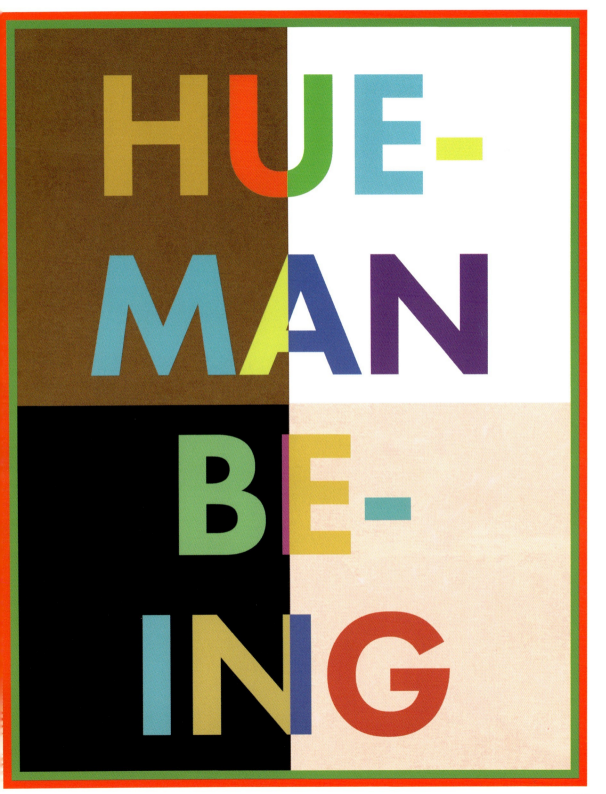

A new meaning that is increasingly important in a divided world of Black and White.

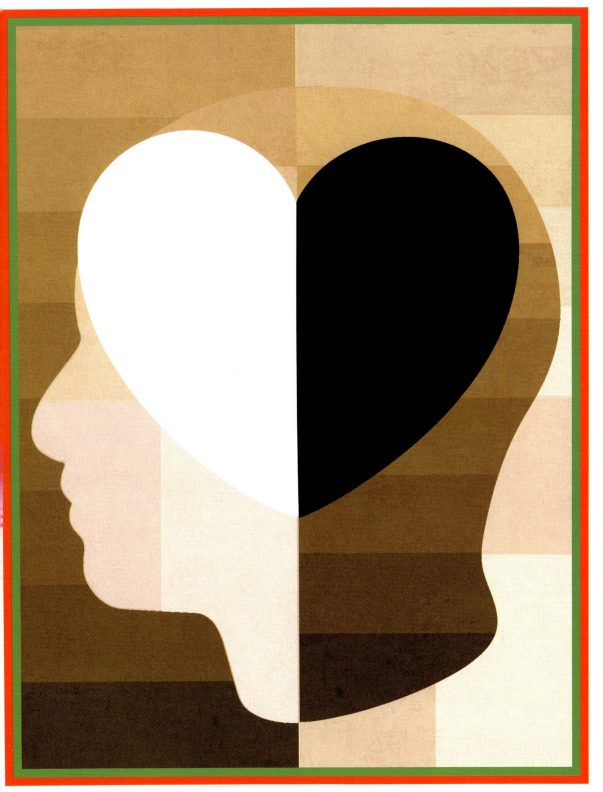

OPPOSITE PAGE: *"Alternate Title of This Treatise."*

THE GREAT MYTH OF THE BLACK/WHITE BINARY REALITY OF THE TOTALLY DELUDED AMERICAN MIND

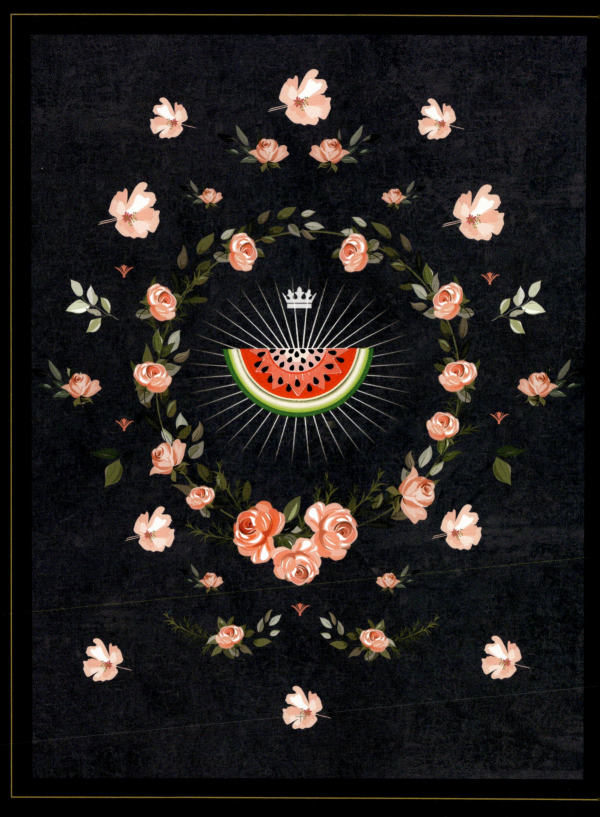

BOOK FIVE

The Apocrypha of Satan Sambo

Satan Sambo's Elegant Solution Pt. 1

Satan Sambo's Elegant Solution Pt. 2

Satan Sambo's Elegant Solution Pt. 3

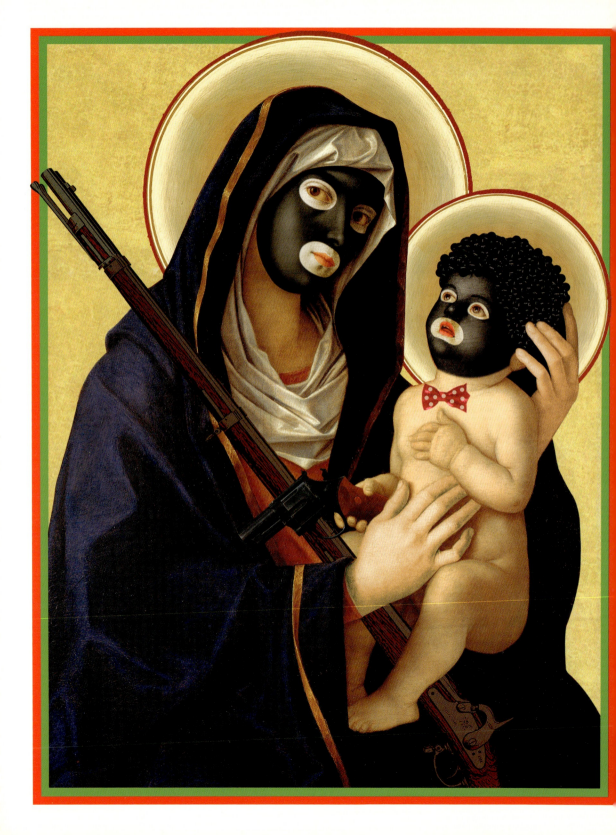

Satan Sambo's Elegant Solution

PART ONE

OPPOSITE PAGE: *"Our Lady and Child of Minstrelsy and Second Amendment Solutions."*

"The ENIGGERMA is the twists and turns, the ups and downs, the lefts and rights of Black American life's complex, existential, maze-like perplexity," said Satan Sambo.

"The most insidious part of the ENIGGERMA is many people think it doesn't exist. You know — like the devil. They believe the ENIGGERMA is just a made-up word. But I submit that new words are needed for freshly perceived realities purposely overlooked."

"Did you know that ENIGGERMA was in the English Dictionary at one point? But it was taken out. Because White people thought that its inclusion brought too much truth to Black people, and they feared that this one concept could make Black minds freer."

I laughed. I knew he was joking. He did that a lot. He made jokes for the effect of making a pointed meaning. So, I didn't take him seriously. No one could be so sane and rational and be that paranoid and conspiracy-minded. (Yes, Satan Sambo was impressive.)

I looked around me. I was with Satan Sambo on the bus. It was about noon, we were riding #24 and having a good conversation. I was going downtown — Satan Sambo in tow. But I don't think anyone else could see or hear him but me.

"You know," Satan Sambo said, "the word 'woke' has become a pejorative, a negative word — (for White people). They have co-opted it and have forgotten its origins in harsh Black experience and not just our vernacular. Woke has become something else. Woke's meaning has changed into meaning (for White people) 'politically correct bullshit.'

"But for Black people, being *woke* is verily Life and verily Death.

"For, Black people, it means being awake not just to inequalities and injustices, but racial discrimination, prejudice, racial hatred, and the White threat that goes with these things and is very real and no joke.

"But for many White people, 'woke' is merely an inconvenient thought intruding into their mental lives and bothering their conscience and the freedom to do whatever they want and feel.

"It's a foreign idea that indicates their genuine lack of empathy and compassion and their propensity toward denial or distortion of the real state of Black affairs. So wisely (for them), they make fun of it and change its Black meaning. And even more wisely (for them), try to sell Black people on the idea.

"Behold a vision!" Satan Sambo said. "Behold a vision that asks related questions — 'When can Black people defend themselves? When do threats against Black people matter?'

"Behold the vision of Blacks that can be on the offense and the defense. And have 'White' approval for it.

"Behold the vision of the Black God of African-American Mock War and the Instruments of His Passion!"

And the roof of the bus seemingly disappeared, for I saw into another realm. And in that realm, I saw a Black figure with its strong back and backside toward me. And that Black figure was reminiscent of something I had seen before. Reminiscent of a classical engraving of Mars, the Greek God of War, unsheathing his great and mighty sword as he prepares for battle amid the clouds.

But in my vision of the "Black God of African-American Mock War" — I saw a figure not unsheathing a sword but holding a golf club with a red boxing gloved hand behind his back, and he was receiving assignments and advertisement funds from a divine and White source.

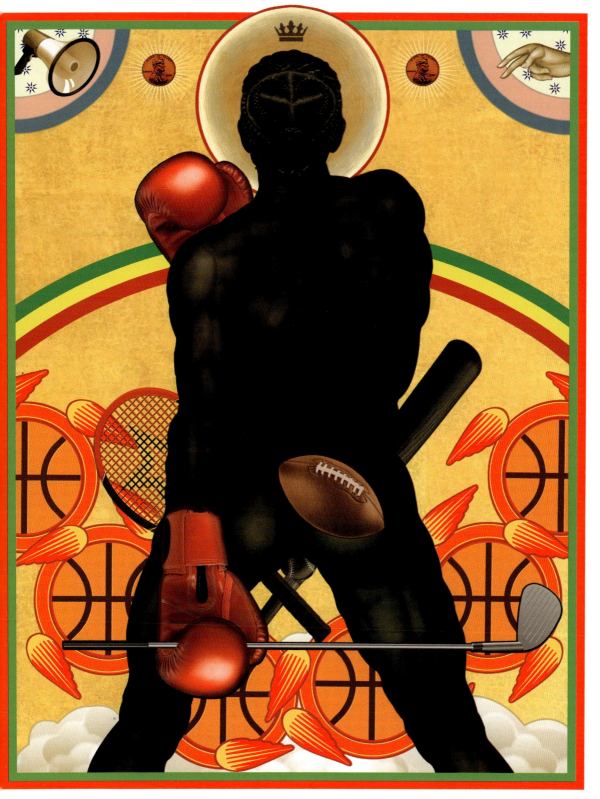

And while I was looking—the vision changed, and I now beheld the Spector of Blue Authoritative Death with Greek columns as crossed bones and the Skull and crossed columns represented the Police State of Ex-Slave Catchers, even the Blue Whip of the Plantation of God and American Capitalism and Democratic Ideals.

And the Divine White Booty was also there as the familiar symbol of hierarchy (as we know already) and of who is at the bottom and who is at the top in Heaven and America. (Though it is a bottom, it is also the top.) This symbol represents the absurd and mysterious yet Whiteous aspect of the ENIGGERMA of American Existence.

And I wondered, was this figure about to make war upon these principalities and powers? Though the figure was unsheathing no great and mighty sword—you can still do some damage with a baseball bat and a golfing club even if you look ridiculous holding it with your hands in red boxing gloves. But, against such entrenched and traditional White power—could he prevail?

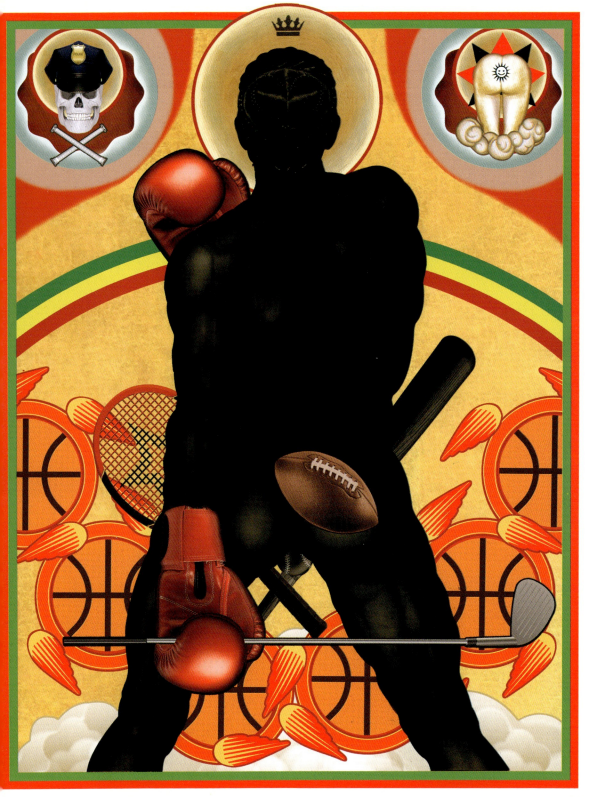

Good luck.

And while I was thinking fondly of a certain good man — Colin Kaepernick…

The vision ceased.

And I said, "Satan Sambo, what do you think of those Black people playing the race card and crying victim all the time?" (I said this knowing it might annoy him.)

And Satan Sambo said, "Your words sound like the words of White pundits and confused "Black" people. But let me explain and try to shed some light on this subject.

"Now, if a woman is raped, is she not a victim of the rapist? A man is murdered. Is he not the victim of his murderer?

"Why do Black people feel compelled to deny their victimhood?

"Is it not to please the imaginations of their ego and assuage Black shame and please those that are White and standing by who will gladly reward them with financial favor and perhaps a pat on the head?

"The deluded seek to impress them and themselves by denying the truth that America has victimized them.

"The history books are clear on this subject. And this is why Critical Race Theory is so hated, and American history teaching about race is banned in many public schools.

"As one of your very own Black sages has said — 'We did not land on Plymouth Rock, but Plymouth Rock landed on us!'* I amend this saying and say unto you, 'And someone threw it! And some "Black" fools are still wondering who.'" He laughed.

Then Satan Sambo said in a loud voice, "**I say unto you that there will be no end to the ENIGGERMA until White people and thus Black people disappear forever!** *Therefore, these present times may be the End of Days or the Beginning of a New World Order — in America. You choose.*"

**Malcolm X*

"What are you talking about, Satan Sambo?" I said. "How might White people disappear? And why would Black people disappear also?

"Are you talking about violence?"

"Oh my God, no! Violence is too simple-minded." He laughed. "*Now, hold on I will answer your question of 'How might White people disappear?'*" he said.

"But first, I have a question of my own.

"Just what color do you think 'White' people are?" Satan Sambo said with a twinkle in his eye.

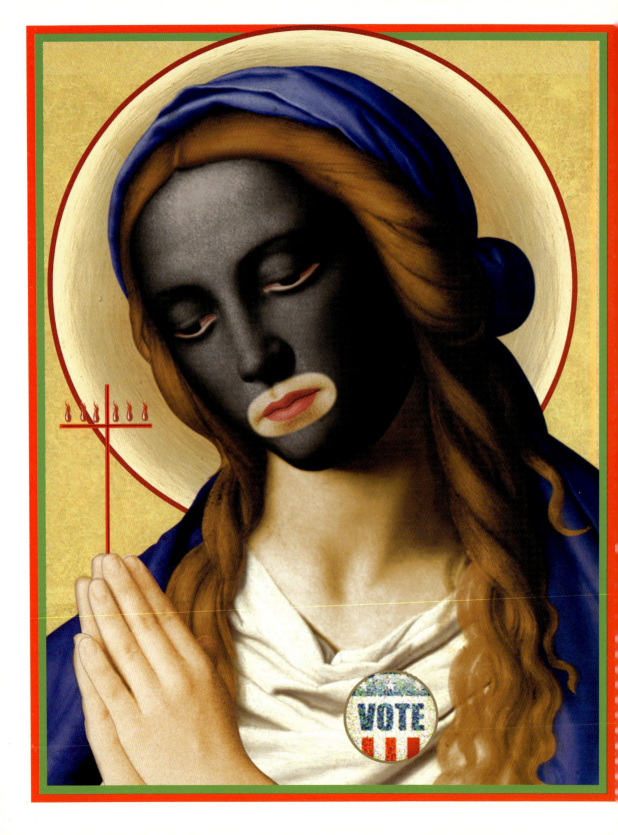

Satan Sambo's Elegant Solution

PART TWO

OPPOSITE PAGE: *Our Lady of Racial Identification, (2 Wokeness), Contemplating Black Lives Matter and the Necessity of Getting Out the Vote.*

"OK. I will answer your question," said Satan Sambo. "But first, I have a question of my own. Just what color do you think 'White' people are?" Satan Sambo said.

"What?" I said.

"White people, so-called. Aren't they light pink or light beige? You are an artist. You know the real deal. Just what color are they?"

(As if my answer didn't matter, he continued to talk without waiting for my response.)

But if he had given me time to respond, I would have probably said "flesh" color. Because when I was a child, I got a pack of crayons in an enormous assortment of colors. And the color that worked best for White skin wasn't called "White" but called "flesh." (I remember this still.)

Satan Sambo went on. "White people have created Black people — you know, not God.

"White people have created Black people through the creative acts of their powerful words. Here, read the English Dictionary, and you might know what I am talking about." He handed me the Dictionary, and I read…

WHITE *adjective* \hwīt, wīt\

1: being a member of a group or race characterized by light pigmentation of the skin: of, relating to, characteristic of, or consisting of white people or their culture [from the former stereotypical association of good character with Northern European descent]: marked by upright fairness // that's mighty *white* of you

2: free from spot or blemish
 (a) free from moral impurity: innocent // the pure *white* heart of the devout **(b)** marked by the wearing of white by the woman as a symbol of purity // a *white* wedding

3: not intended to cause harm // a *white* lie // *white* magic

4: archaic: FAVORABLE, FORTUNATE // "one of the white days of his life" — Sir Walter Scott

"These definitions sound pretty positive," I said.

"Positive indeed!" said Satan Sambo. We looked out of the bus' window upon the crowd of people of different hues and ethnicities that traveled the sidewalks of Mission and 16th near the BART station entrance.

"Now, go in your dictionary to the word 'Black,'" Satan Sambo said. I did and read…

<u>**BLACK** *adjective* \blak\</u>

1: Black or *less commonly* black
(**a**) of or relating to any of various population groups of especially African ancestry often considered as having dark pigmentation of the skin *but in fact having a wide range of skin colors* (**b**) of or relating to Black people and often, especially to African American people or their culture

2: DIRTY, SOILED

3: old-fashioned / literary: thoroughly sinister or evil: WICKED
 (a) indicative of condemnation or discredit // got a *black* mark for being late

4: connected with or invoking the supernatural and especially the devil // *black* magic

5: very sad, gloomy, or calamitous // *black* despair
 (a) marked by the occurrence of disaster // *Black* Friday

6: characterized by hostility or angry discontent: SULLEN // *black* resentment filled his heart
 (a) distorted or darkened by anger // his face was *black* with rage

"Not too positive?" Satan Sambo said.

"Not too," I said.

"This is what I humbly think," said Satan Sambo. "I think that over many centuries, White people's insistence on being white and on Black people being black has wholly worn us out. And we have thrown up our hands in defeat and have given up on fighting them on this point. We caved. We have given up being Colored and Negro, and even Human. As in H-U-E-man," he said with a wink.

"And now, we are officially both 'Black and Proud.'"

"And 'Black and Beautiful,'" I said.

Satan Sambo said, "Go back to the first definition of 'black' which reads…'(a) of or relating to any of various population groups of especially African ancestry often considered as having dark pigmentation of the skin *but in fact having a wide range of skin colors.*'

"Isn't that curious?" he said. "Are Black people black?"

His laughter had a gratingly sardonic shrill tone to it. I started to realize why people might call him "Satan Sambo." (But also, the horns and jet-black skin were dead giveaways.)

By some, he is said to be the younger brother of the illustrious Saint Sambo and a creature of chaos like Loki, brother of Thor. But others believe he is Saint Sambo himself in a prophetically predicted return and he is the prophesied Uncle Saint Sambo* in disguise.

"This is how White people created Black people — by creating themselves," he said.

Then he sang a ditty.

* *See* The Gospel of Saint Sambo *"The Burning Cross of Liberty"* page 212.

THE DITTY OF SATAN SAMBO.

"Is there an up without a down?
Is there dark without light?
Is there left without right?
Is there Black without White?"

And then he said, "Therefore, there can be no White people without there being Black people also.

"That's why Black people can never **ever** be brown people. Black people can never ever be brown because White people are white...*and not pink or beige.*

"Are you with me?" he said, and continued speaking. "And since the definition of 'white' is positive, and the definition of 'black' is negative, then labeling people 'white' is a form of mental manipulation and a sly piece of propaganda, and the labeling of people 'black' is also a form of mental manipulation and a sneaky slur. (*Those damn "White" people are smart as hell* — I tell you. You got to watch out for them.)

"**BA DOOM!**" He said.

"I believe both White and Black people are now convinced in their unconscious minds (especially their children) that White skin is white as pure alabaster and Black skin is black as coal.

"This perceptual distortion and coup of the unconscious mind demonstrates the creative power of words. From ancient times people knew the power of words to shape our minds and perceptions. There is magic in them. To spell out a word is to cast a spell. That is why it is called 'spelling.' You dig?"

"I agree. There is some creative power at work in words," I said. (Finally getting a word in edgewise.) "Is it not said in the Bible that a Word brought the whole of creation into being?

"And yes, Satan Sambo, you are right. Many Black people are brown, and some are caramel-colored. And some 'high-yella.'

"And some are almost pink or beige, and therefore rivaling Whiteness itself. But I have heard this before. Nay, read it. This is all in THE GREAT MYTH OF THE WHITE/BLACK BINARY REALITY OF THE DELUSIONAL AMERICAN PSYCHE!* Are you familiar with this text?"

And Satan Sambo said, "Yes, I am the author of it. And I say unto you, must not those called "White" and those called "Black" forever be caught in a *spell of opposition* and of worlds that collide? Worlds that are against each other, even in some way in continual conflict of otherness and exclusion?

"Even a battleground of WHITENESS and BLACKNESS, a battleground of creative words, insistent upon defending each other's reality based on being opposites, even in a war, clearly demonstrated by our historical past, as being of very human life and very human death?

*Page 291

"Do you know what one of the most exasperating things about THE GREAT MYTH is?" Satan Sambo said. "It is its ineffectiveness. I believe that after all of this time, the common White person (for they are not all masterminds) still doesn't understand that they will cease to exist without someone being considered "Black."

"I don't think many people understand this principle and truth properly," said Satan Sambo. That truth being that if they wiped out every Black person in the country (*not that I am saying they **all** want to, but if they all wanted to they indeed could*), they themselves would cease to exist in some fundamental way after doing so.

"Perhaps in facing that reality of ceasing to exist as 'White' people, this will reveal another path they might take. And that path is to use the creative power of words again.

"To make those now regarded as brown (who are almost their color) and label them to be Black instead."

"Didn't they do this to the Italians and (I think) even the Irish? *Black Irish*. And they weren't even 'brown,'" I said.

"Yes, they did," Satan Sambo said. "For having "niggers" and labeling them 'Black' is always useful for those of a 'higher' status. And under such circumstances, that might be the fate even of some of these that we see before us right now?"

Satan Sambo jutted his chin out, pointing to the crowded sidewalks outside the bus window.

There were lots of Latinos around.

And that brought to mind a Latino woman I briefly dated many years ago who told me she was white. In my then naivete, that thought was something novel. Of course, it seems foolishly apparent to me now that she was right. She was as "White" as any "White" people I have seen.

And Satan Sambo continued, saying, "And if they then wiped these newly so-called 'black' people out? What then? On up the ladder? Wiping out every hint of melanin and pigmentation until there is none left and then — poof!

"There would be no more need for the label of 'White' people in this scenario. There could now be only people. Just humanity. Real humanity being humane to each other. Utopia. Without different classes and all equal in nobility and kings of their own American castles.

Paradise. And there will be no repeating Europe's past before Black people came, for now they are imbued with American democratic values and ideals which guide them." Satan Sambo looked at me. Satan Sambo laughed.

"Surely they won't fight and kill each other for they would now have the White utopia they yearn for. Right?" he said.

At what significant cost are such final solutions? I thought. Then I asked Satan Sambo, "Is there another way of bringing about peace and unity without all that wiping out stuff?"

"I am convinced there is," Satan Sambo said. "By the way, and for the record, I find, as with violence of all kinds, that the wiping out of whole races of people is personally and morally objectionable."

Then he smiled. "And what I have in mind is so much better…*it's my elegant solution.*

"You see, the goal of my plan would be to convince 'White' people to abandon their cherished position of Whiteness, just like we abandoned our one-time cherished position of being anything but Black during our Negro and Colored days when being called black were fighting words.

"Alas, yet we became 'Black' anyway despite ourselves. Ha! Ha! Ha! Ha!" he laughed.

"So, about your plan, Satan Sambo," I said, "you can't be serious. To convince White people to cease to be White? That would be an impossible feat. I think White people like being White. And who has the power to force **them** to be otherwise?"

"But think about it for a second. Just hypothetically," Satan Sambo said, "with White people not being White…we might just have a better country. For perhaps then the conflict based on constructs and color could cease.

"And getting spiritual—I believe the Plantation of God along with the principality of the Divine White Booty of God—even that same cosmic principality that demands to be kissed, adored, and revered—and even the very symbol of White supremacy—without the spell of Whiteness—it shall be threatened. And who knows? Perhaps the Divine White Booty too might finally come to an end.

"Well, the Divine White Booty of God is an 'end' already of a sort," I said. "Though *A Divine White End* but an **end nevertheless**." We laughed.

Now, Satan Sambo started to get all weird and intense. Talking about the Divine White Booty must have struck a nerve.

"*Don't believe the Divine White Booty and its propagandists!*" he said. "Yes, I am a revolutionary. I admit it. I am also a cosmic mastermind, but I am mainly a humble inter-dimensional being fighting the good fight against the status quo and against all odds and a White and mighty God. And I am down here on Earth for the benefit of all humankind! Not just Black folks. But both 'White' and 'Black' and all those in between!

"You see, the Divine White Booty of God might favor White people," Satan Sambo said. "But let it be known — I do not! I see the whole globe as a community."

At this point, I decided to challenge Satan Sambo a bit. "But I don't understand," I said. "If you are so 'good,' why do you look like a devil?"

"What you see," said Satan Sambo, "is merely the Inversionistic Visual Language of American Symbolism Made Manifest by the Pervasive Illusion of the ENIGGERMATIC Mental Construct."

"It is like when you are Black — 'Good' can be 'Bad' and 'Super Bad' can be 'Kool.' And 'Kool' can be 'Hot' (or 'Haahhhht!') and etcetera. This is America, 'baby.' (Yet, you are not an infant.) Can you dig it?

"Let me put it more concretely. Black people doing good are demonized if they are helping out Black folk. Just like Martin Luther King Jr. was considered to be the most dangerous man in America back in the day. And yet, he was all about non-violence. And in our day, Obama was considered to be a Black Hitler and possibly the Anti-Christ himself. Black changes everything — even brown skin, you know that. And now that MLK is dead — because death has neutralized him, and he is no longer 'dangerous' but a known commodity (and thus tamed) — the same people are singing another tune like they are doing with Muhammad Ali and (to some extent) Malcolm X.

"But I am not planning on dying anytime soon. And I am not easily killed.

"Besides, people see and hear what they want. My true form is not easily seen, nor is my true name easily heard.

"But I do favor the underdog, though. You know, the whole 'first shall be last, and the last shall be first' — that sort of thing. This might give you a hint — of who I truly am.

"And so, that you can better understand the basic premise of my 'elegant solution' — behold this vision! Indeed, behold a vision that illustrates the difficulty that even Divine Whiteness has in identifying with Divine Blackness and vice versa. (Therefore, what should we expect from ordinary Whiteness and Blackness?) Behold a vision of, 'Our White Lady and Child of Black Identification.'

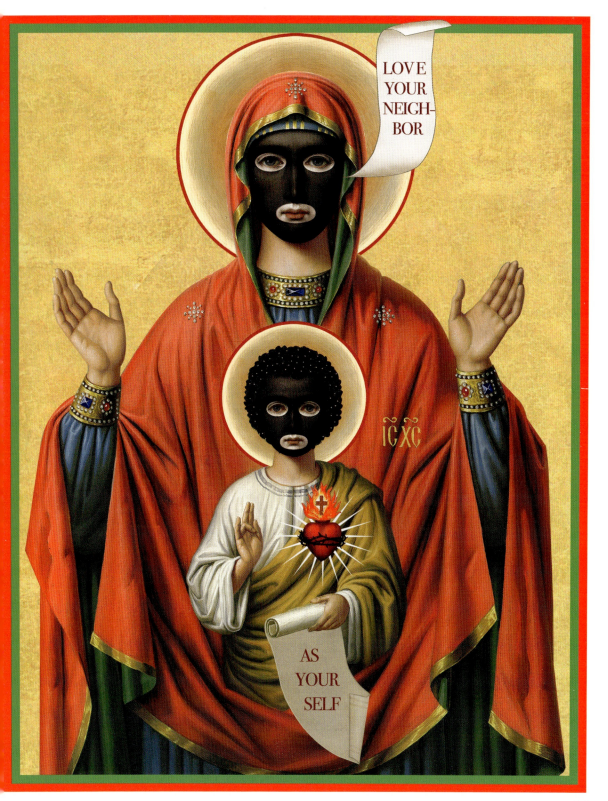

"Do you not see the difficulty of this vision?" (Satan Sambo said as the vision continued to be revealed.) "I want you to seriously ponder it. Look at it! Look at it! And you might see this difficulty. However, let me give you a cue.

"And let me start here.

"In the Great Gnosis* it is purported that the Buddha said, '*With our minds, we make up the world.*' But I amend this saying.

"I say, '**With our words, we make up our minds.**' And with the use of words like 'White' and 'Black' as human descriptives, our minds have been made up already. Made up to dwell in a reality of opposition, hierarchy, and conflict before any outward action has been taken.

*page 258

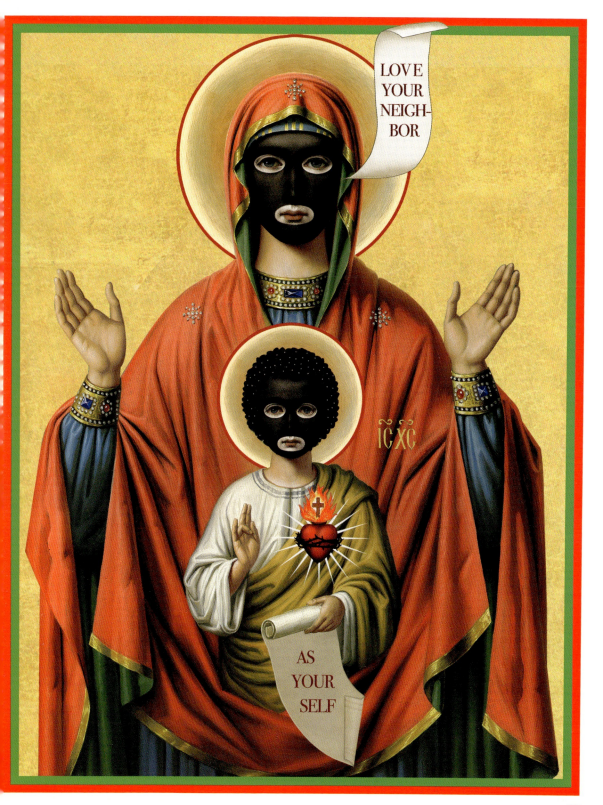

"So much so, any Black or White divinity cannot overcome the oppositional effect of these opposing words and concepts. No Black or White God can save America.

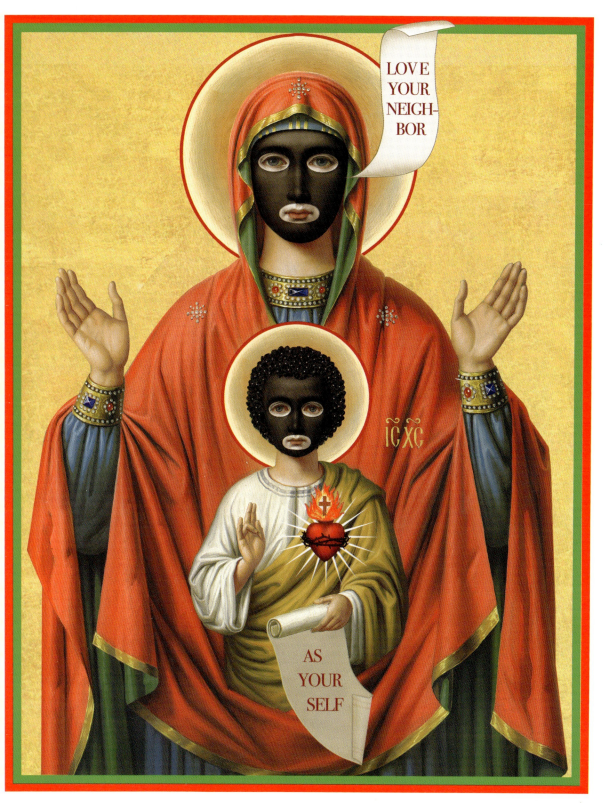

"Therefore, I perceive that our problem is on the level of initial thought patterns," Satan Sambo said. "This is where the 'otherness' reality, and its influence holds sway. And if it holds sway inwardly, it holds sway outwardly.

"But what if we diminished the sway of concepts at its very textual root? What then…?"

"Perhaps therein lies redemption and hope for a whole nation," Satan Sambo said, and then quoted a prophet and a sage.

> *We live in our language like blind men walking on the edge of an abyss. This language is laden with future catastrophes. The day will come when it will turn against those who speak it.*
> —Gershom Scholem

"And that day has come after centuries here in America," Satan Sambo said.

Satan Sambo's Elegant Solution

PART THREE

"Taa Daa!" Satan Sambo announced.
"Well, I have been waiting," I said.

Now, let me whisper to you this 'elegant' solution, even the solution that will solve all of our racial problems in America and discombobulate White minds even if only implemented by the 'Black' people.

He then leaned over, and his mouth came within an inch of my ear. And I heard him spell one word. He whispered, "*P-I-N-K*." Then he said,

"Say pink until the 'White' people say, uncle."

"That's it in a nutshell, my elegant solution. That's it! Right there! Boom!" he said. "You can say beige also. But my preference is pink."

He then leaned back in his bus seat as if he was lounging in a Lay-Z-Boy chair with his hands behind his head and his feet up — quite satisfied.

Then he suddenly moved closer to me and looked me squarely in the eyes with a surprising intensity. At that moment, it was like his eyes grew larger and glowed; they were all I could see in a vast, dark field of blackness.

(The bus backdrop and all the people on it, with their busyness and private concerns, had fallen away.) And there was only silence and Satan Sambo's voice speaking in a loud stage whisper, and he said again,

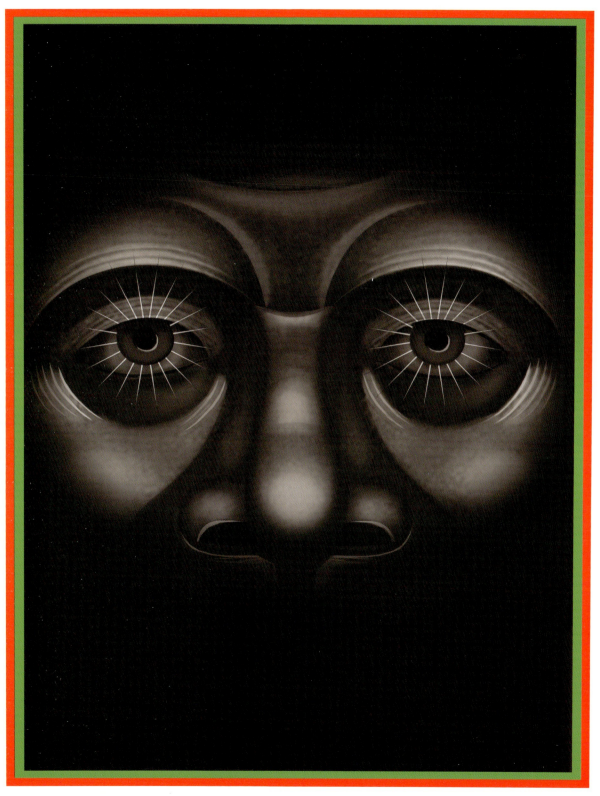

"Say pink until the 'White' people say, uncle."

And the light in his eyes communicated directly to me, and it penetrated my soul, and I swooned.

I had another vision!

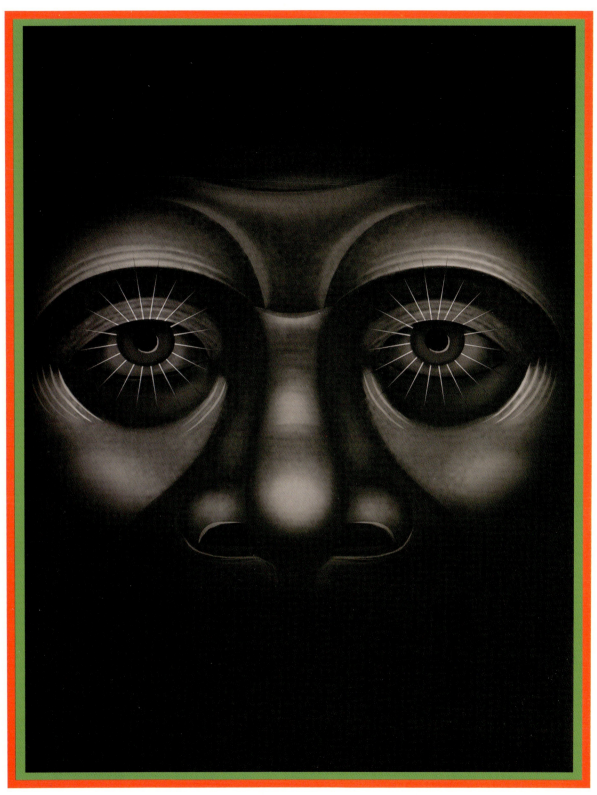

And I saw Satan Sambo. He was in the heavenly realm. He was exalted and lifted high up by an Unknown American God, and stars surrounded him. And he appeared on a throne where a rainbow sat, and he sat on the rainbow and the throne simultaneously.

Satan Sambo was clothed with shimmering robe over a green suit, and in his left hand, he held a tenor saxophone with fire in the bell. Satan Sambo had on snazzy black shoes.

And in his right hand, he held a scroll, and written on the scroll was this…

"Say pink until the 'White' people say, uncle!"

And I heard the voice of the Unknown American God say, *"Beautiful are the feet of they that come with good news!"*

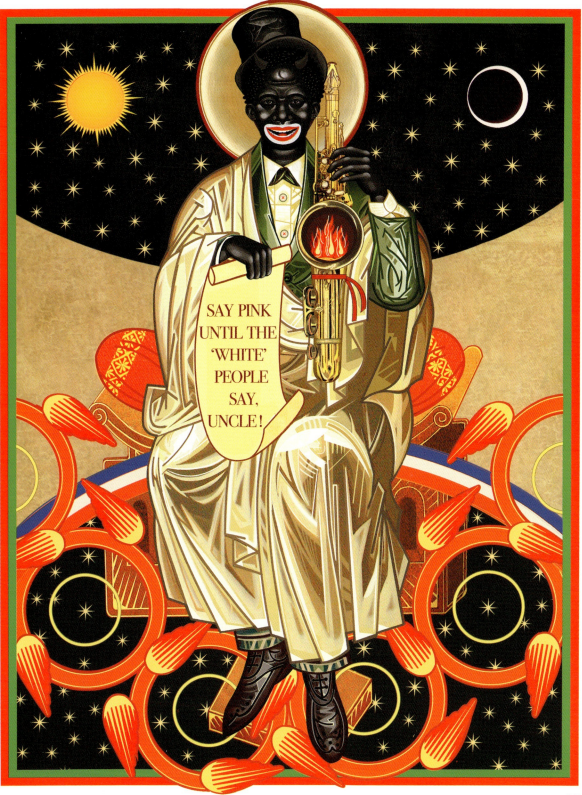

I asked Satan Sambo why did he now appear before me as he did.

Satan Sambo replied, "I wear the bright robes, the green suit, and the snazzy shoes of John Coltrane, also called the Divine Sound Baptist.

"I even hold in my hand a tenor saxophone with fire in the bell, and that has a ribbon tied around it. And that ribbon is a sign of the mutual gift-giving of an Unknown American God that Coltrane confessed. For he believed that we receive our gifts from that Unknown God and His Wise Ones offer those gifts back to Him in service to realize the greatest ideal and virtue in gratitude.

"Therefore, I appear as I do before you because I believe in that Greatest Ideal and that Ultimate Virtue of this American Unknown God.

"You see, I believe in 'A LOVE SUPREME,' and I say unto you, **the Divine White Booty of Mammon and Jes'U.S. Christ and its Ass Holy of Holy DO NOT!**"

"Those of 'A Love Supreme' have achieved an inner vision of the Unity of All Things. They subsequently see the world as a community. That means everyone is seen as a neighbor. (This would help with our global crises and many of our national social ills.)

"Can you not speak and think the truth for yourself? *So, are you really black,* **Black Man with Brown skin**? And if you are, then you are forever in opposition to Whiteness. And opposition is not unity.

"It appears that it is up to you to save a whole country and perhaps even the whole world!

"For has it not been written — '*And lowly things of the world, and things which are despised, hath God chosen, yea, and things which are not, to bring to naught things that are.*'

"'That no flesh should glory in God's presence?'*

"Must you be in opposition to Whiteness even if Whiteness is in opposition to you?

"That is my question. For the words 'black' and 'white' are indeed opposites. And again I say unto you — **With our words, we make up our minds!**

"*Words are the basic ingredients of the Great Spell this nation is under.*

"***Different words — different thoughts — perhaps different perceptions and outcomes?***"

Satan Sambo became silent.

*1 Cor 1:28-29

Kumbaya?

Maybe. Yet, I started to see Satan Sambo's salvation, his confounding project, and why many of the Idolators of the Great Black and the Great White Way will never heed him and others will hate him, being confused by his great wisdom and inversive appearance — and others will think his ideas are just plain dumb.

For wisdom is foolishness to fools.

However, many who are enlightened and of a good heart will love him.

You see, Satan Sambo wants to replace our present limiting mindset and small-minded affiliations based on the polarity of American tribe and herd with something more elevated.

"What is that 'something more elevated?'" You might ask.

It is that important thing that is spoken of at the end of THE GREAT MYTH OF THE BLACK/WHITE BINARY REALITY OF THE DELUSIONAL AMERICAN PSYCHE. It is attained through understanding and going beyond the Black and White myth of duality and race.

"In essence, it is accepting the sound principle of '*Many Hues but **One Humanity***,'" Satan Sambo said to me telepathically — *of course...of course...he can read my mind!*

"Yes I can," he said.

And while on the bus, that day, and in my heart — I was convinced. For I had already solved the cipher of Satan Sambo, having gone beyond the sway of his inversive appearance.

And in my heart, I sang a new song.

I am not Colored
Anymore

Nor am I Negro
Nor am I Black

Anymore

Nor am I Whiteous
Anymore
I am not a color
I am merely human
And my mere humanity
Is enough

And so as a wise compromise
with a foolish and intractable world
I will allow it to call me...hue-man
(Which has a color component)
That's my only compromise
If 'human being' is too much to ask

Selah

"I am he that has been foretold," Satan Sambo said. He stood up and spoke to me from the middle of the aisle of the bus. "I am the Last Test of this Nation. Saint Sambo has spoken of me! And he called me the Black brother of Uncle Sam, even Saint Uncle Sambo!

"For I am a test of American vision.

"And I offer you the gift that has been veiled in the very Spirit of American Liberty.

"I offer you a way of empathic equality. A way to go beyond Blackness and Whiteness, forever!"

"I am that Cipher to Be Solved. To some, I am a repellent mystery; to all, I am a puzzle that resists easy resolution, for I appear black and uncomely, but actually, I am not Black but hue-man and human at the same time, and through great hardships, I am proven to be the fairest of all!

"Can you solve the conundrum of your dark hearts?

"Can I not be comely in the eyes of a great nation?" (Satan Sambo started to walk down the bus aisle, then he suddenly turned and looked at me with glaring eyes.)

"Can you not get past whom I appear to you to be — and enter into the very substance of my mere humanity?

"Some people think I am talking to 'White' people only." He looked at those on the bus. "But I am talking to both 'White' and 'Black' people, for both are deceived.

"Now, behold my sign. For this nation shall not be saved except through the acceptance of my Black body, and this body becoming Post-Black and other bodies becoming Post-White, thus ending the Great Conflict and embracing the 'apparent' kumbaya of 'A Love Supreme' and a hidden unity.

"For Saint Sambo was a revelation of accommodation to 'White' power, and many loved him in his day. But revelation can be progressive, and I, Satan Sambo, am the end result even of going beyond a mythic melting pot of assimilation and into true acceptance and community and fellowship nationwide.

"Look upon me! How can you bear such holy contradictions?

"Can you not see? My revelation is greater than White Jes'U.S. Christ of Mammon and his Apartheid Nigger Heaven and Celestial Coon Christs and Divine White Booties!" (Obviously, he was now speaking to all that were on the bus. *They could see him!*)

And he raised his voice, slowly surveying his seated and captured audience. "Can you not see? The Coon Christs were White Ass Holy. Yea! And I say. Yea, again! **They were White Ass Holy!** For they have done everything they could. And having borne all — yet it appears it is still not enough.

"So we have arrived here, still at odds in spite of their great Whiteous feats of enduring greater hardships. Go figure.

"And verily, I, Satan Sambo, say unto you…

"I TOO BEAR THE BURNING CROSS OF LIBERTY!

"For I am smart and strong! And I know it! I bring with me the knowledge of the *difference* between Good and Evil to a nation confused by 400 years of Whiteousness. Yea! I am invisible. Which doesn't mean I am not seen. *But that which is seen is not me! It is only a **delusion** of me.* Finally, so there will be no doubt — I say to you all — I too believe the ENIGGERMA exists! And I am caught in it.

"Now, to crack the code of my appearance, simply answer the questions below.

"If the devil can transform himself into an angel of light — can not a prophet of God appear to the foolish as the devil?

"And a holy seer appear as Satan himself to the deceived?"

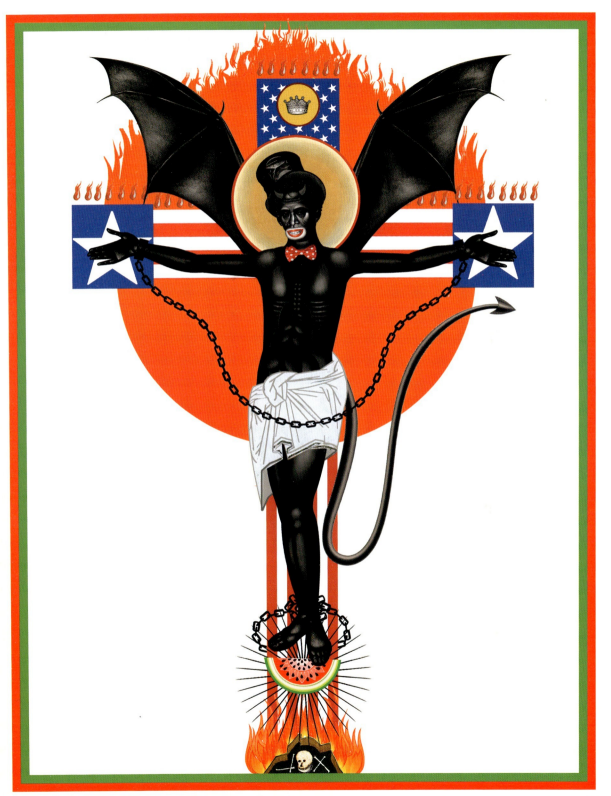

Finis

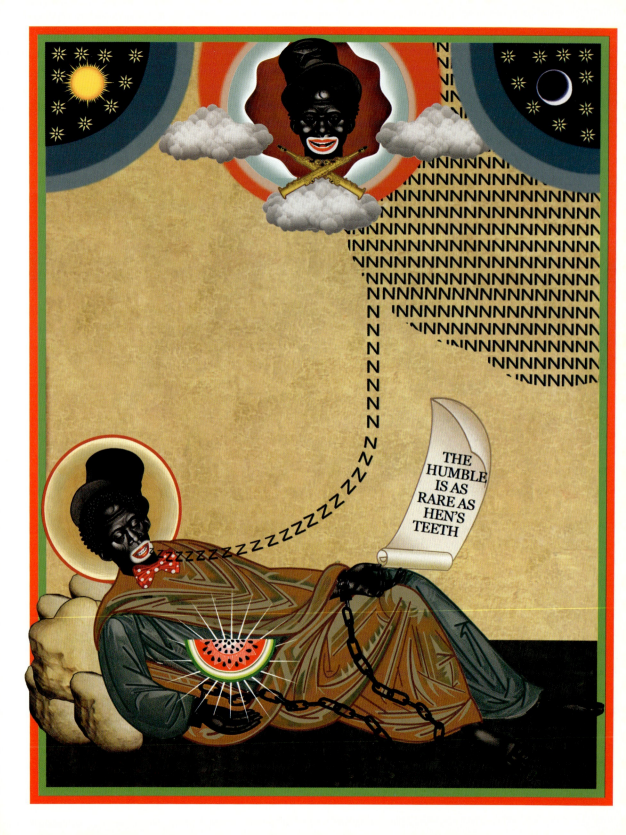

OPPOSITE PAGE: *The Peculiar Sabbath Rest of Saint Sambo and Satan Sambo with his Head in the Clouds Preaching the Kumbaya of 'A Love Supreme.'*

Afterword

TO MY ESTEEMED FRIENDS, respected beta readers, and unwavering supporters — the mystic Archbishop Franzo Wayne King, Rev. Peter Schell, poet Solomon Rino, Rev. Stephen Hassett, Prof. Aldo Billingslea, cartoonist J.D. Lunt, Dr. Nicholas Baham, and my companion/assistant Anilchana Padungdachavratat and her family, especially beloved "Ma" and "Paw" (her parents) — I am overwhelmed with gratitude for your steadfast presence and invaluable contributions. Your feedback, encouragement, and support have been instrumental in shaping the essence of *The N-Word of God*.

I would be remiss if I did not extend my heartfelt appreciation to Dave Hurlbert and Scott King for their graciousness in opening their beautiful home atop Telegraph Hill in San Francisco and allowing a sizable and interested crowd from St. Gregory's, Saint John's, and beyond to gather for a profound "Saint Sambo" reading and "soiree of a sort" (so avant-garde and so very cool and hip) during the early days when this nascent project was crystalizing into a book form. The energy and passion of that event permeated our conversation then and catalyzed the ideas and concepts that now fill these pages.

I owe immeasurable gratitude to the Rev. Rick Fabian, Rev. Donald Schell, Leesy Taggart, Marci Mills, Marie Mosher, John Golenski, the Saint Gregory Nyssen Episcopal Church community, and the Coltrane Church community. Your unwavering dedication to the craft of my icon artmaking has been an integral part of my artistic journey, paving the way for the development of Byzantine Dadaism (Byz Dada), my present expression. Within the embrace of the Coltrane Church community, I discovered the transformative power of John Coltrane — a Jazz Musician, Composer, Philosopher, and Saint. The resonances of "A Love Supreme" have indelibly been imprinted upon my life and this creative endeavor.

I sincerely appreciate my esteemed patron, Rev. Dr. Mark Bozzuti-Jones. Your unwavering support and boundless inspiration have served as a guiding light throughout this artistic pilgrimage. Your steadfast belief in my vision and unwavering dedication to nurturing its growth has been nothing short of miraculous and transformative.

Finally, I wish to express profound gratitude to Dr. Lynn Jones of Florida State University, Dr. Rosetta Giuliani-Caponetto of Auburn University, and Dr. Christine Joynes of Oxford University. Your generosity in allowing me to share the art and ideas encapsulated within The N-Word of God with your respective students and faculty has been truly remarkable. Your scholarly appreciation and engagement have immensely contributed to the evolution of this work.

And very lastly, a thank you to my publisher and editor, Gary Groth, a true visionary in the genre of "words and pictures," who supported my vision and voice along with his wonderful team at Fantagraphics Books, especially Kayla E., my creative director and graphic designer on *The N-Word of God*, your enthusiasm, creativity, and attention to detail have indeed brought my vision to life, and I'm incredibly grateful for your contributions to making this project a success.

As you hold this book in your hands, I hope you discover within its pages a reflection of the collective inspiration I have received from these extraordinary individuals and communities, without whose help, this work would surely be diminished. Authoring *The N-Word of God* has been an artistic culmination and a journey of discovery, introspection, and the attempt to explore relevant themes that reveal specific patterns and shapes I have seen my whole life that are rarely made clear and sometimes never spoken of. I hope it resonates with the reader *as only art can* and enriches the reader's life.

With utmost appreciation,
Mark Doox